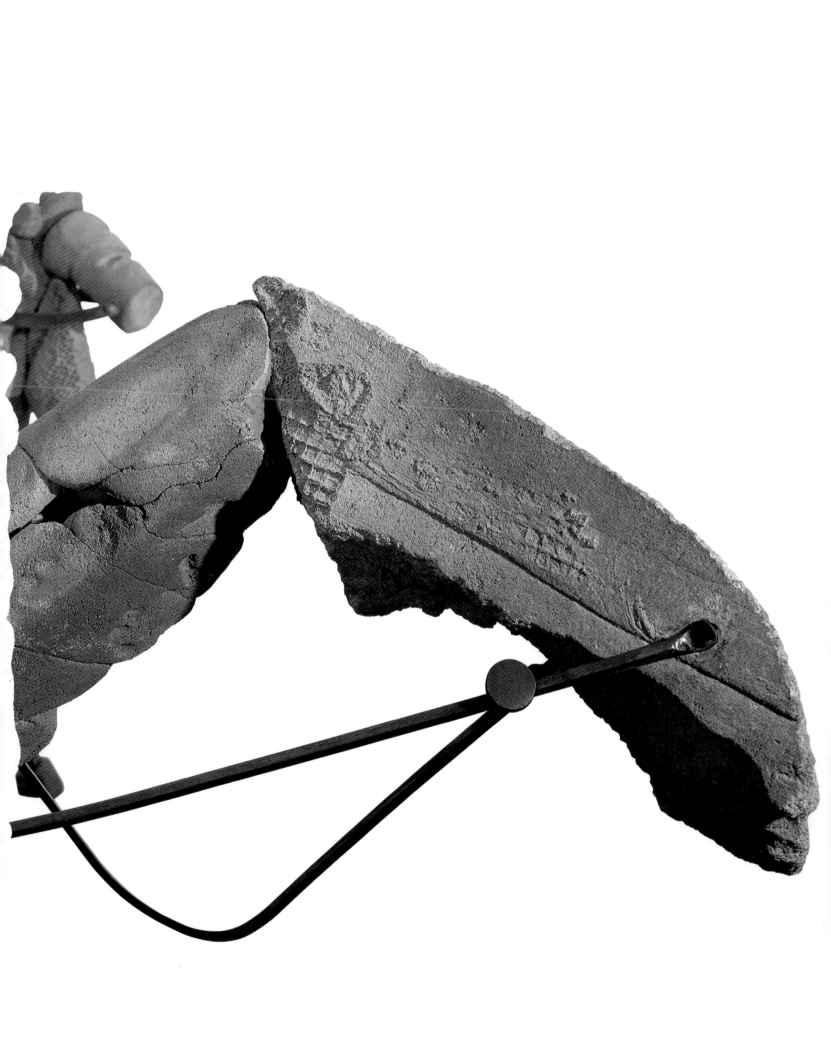

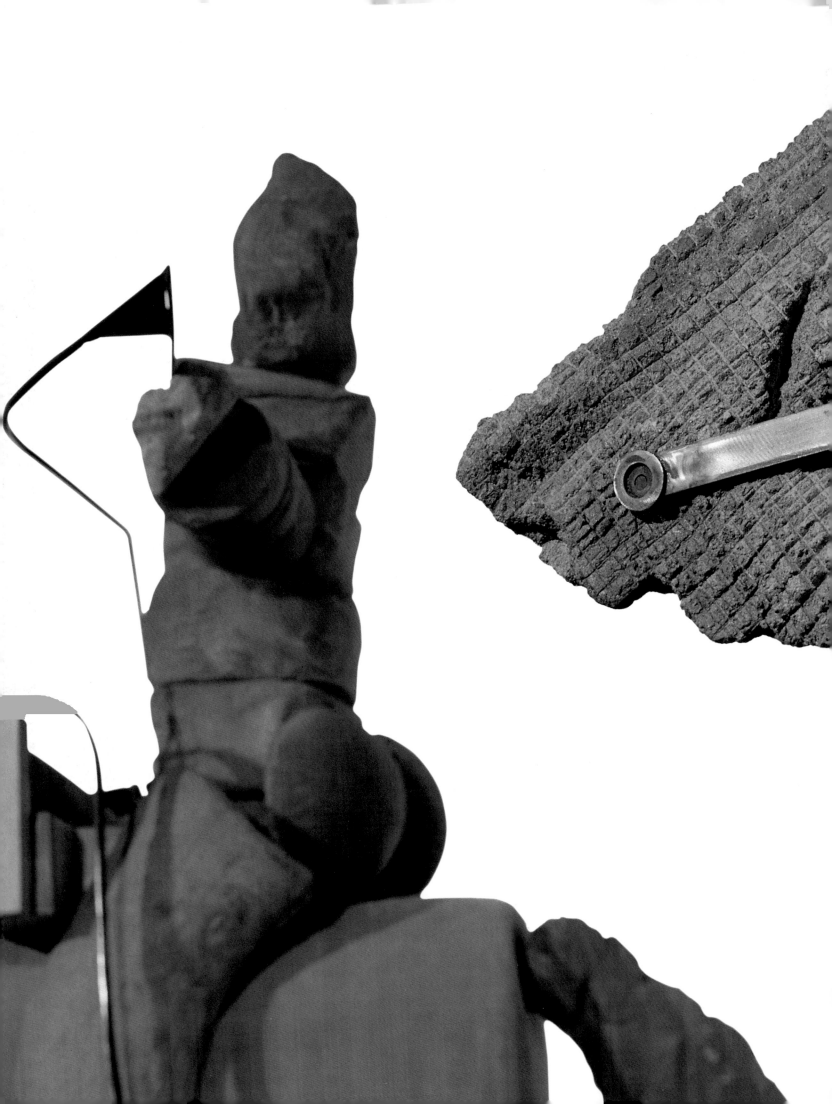

From The Age of Anxiety

1944-46

W. H. Auden

... out of the north, from

Black tundras, from basalt and lichen,

Peripheral people, rancid ones

Stocky on horses, stomachs in need of

Game and grazing, by grass corridors

Coursed down on their concatenation

Of smiling cities. Swords and arrows

Accosted their calm; their climate knew

Fire and fear; they fell, they bled, not an

Eye was left open; all disappeared...

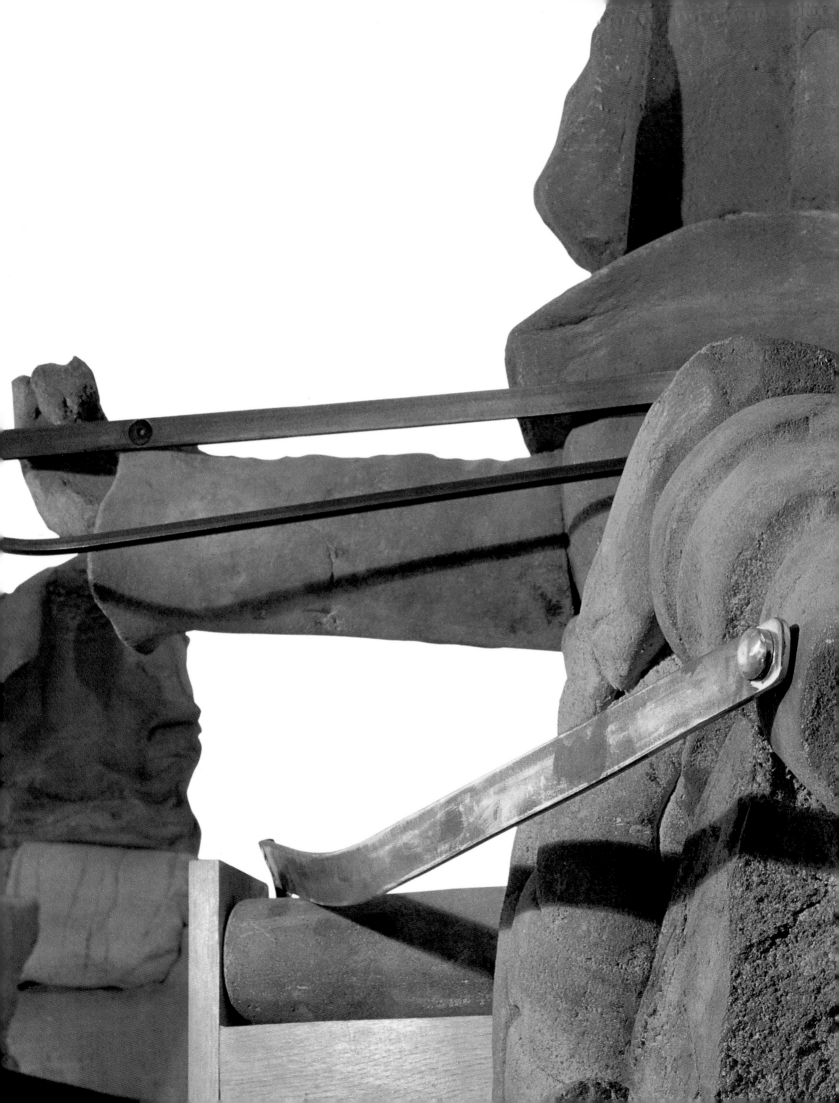

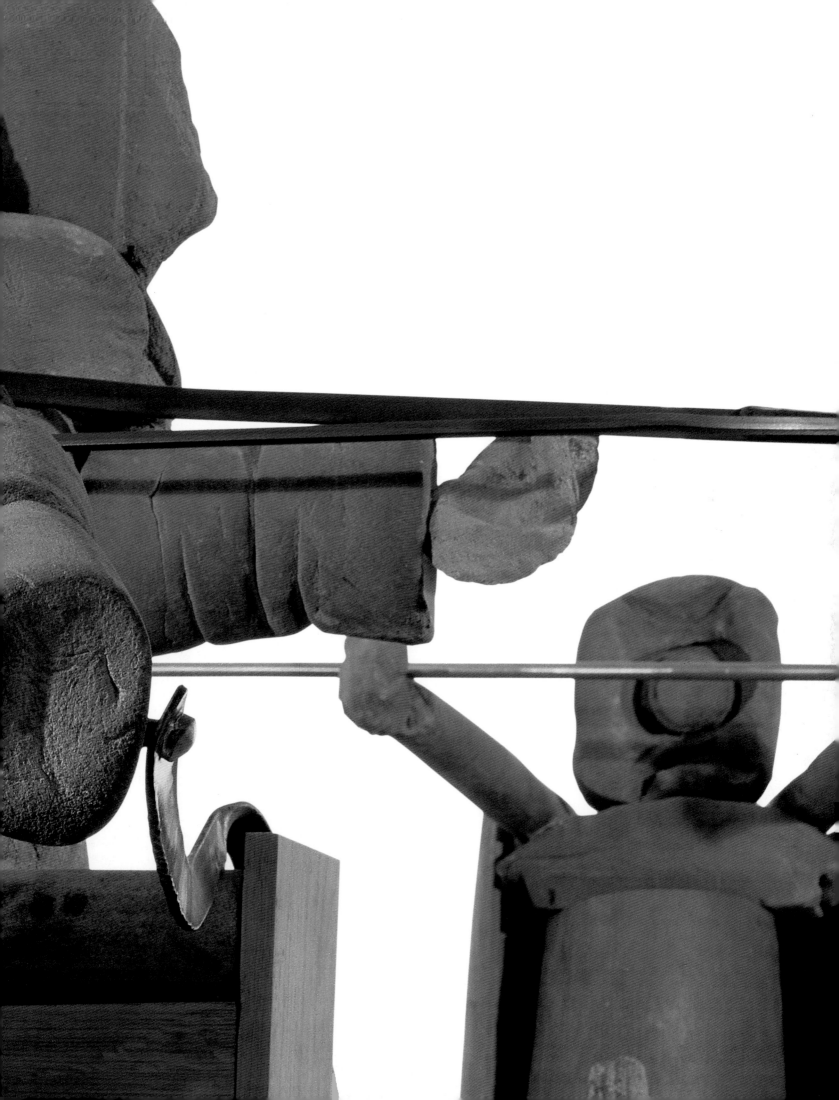

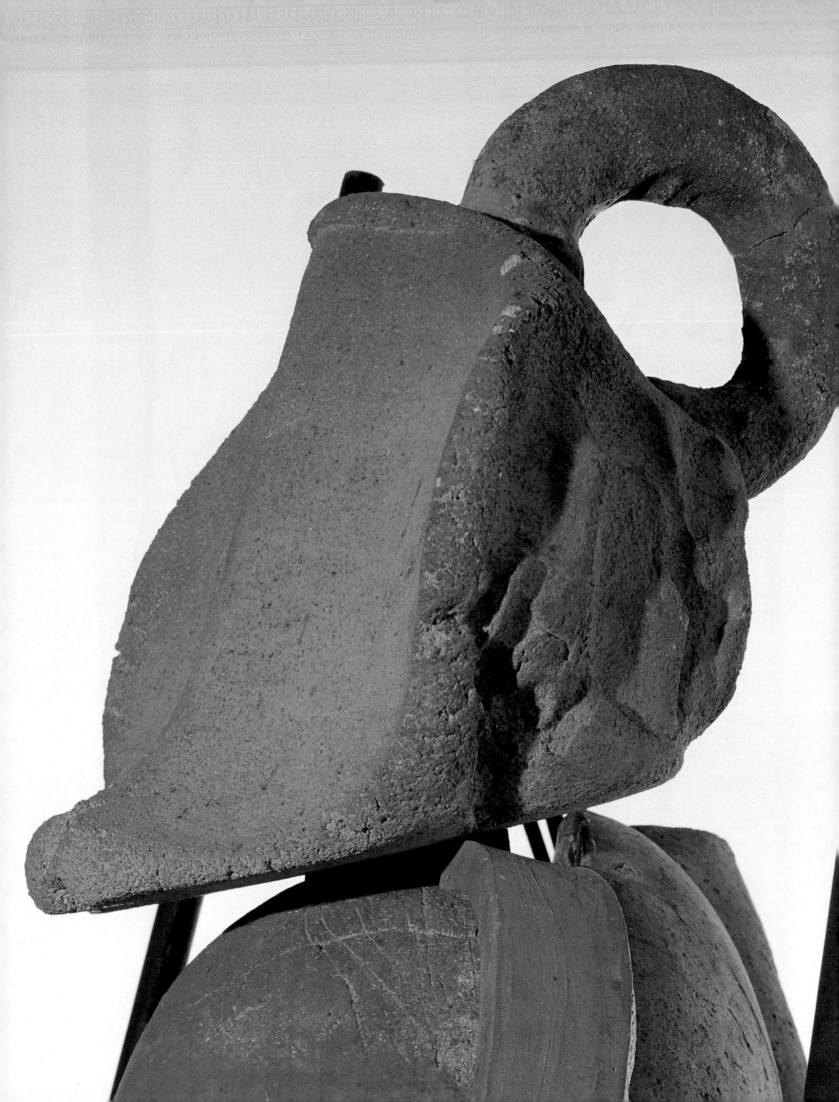

Waiting for the Barbarians

1904

Constantine P. Cavafy

What are we waiting for, assembled in the forum?

The barbarians are due here today.

Why isn't anything happening in the senate?
Why do the senators sit there without legislating?

Because the barbarians are coming today.
What laws can the senators make now?
Once the barbarians are here, they'll do the
 legislating.

Why did our emperor get up so early,
and why is he sitting at the city's main gate
on his throne, in state, wearing the crown?

Because the barbarians are coming today
and the emperor is waiting to receive their leader.
He has even prepared a scroll to give to him,
replete with titles, with imposing names.

Why have our two consuls and praetors come
 out today
wearing their embroidered, their scarlet togas?
Why have they put on their bracelets with so
 many amethysts,
and rings sparkling with magnificent emeralds?
Why are they carrying elegant canes
beautifully worked in silver and gold?

Because the barbarians are coming today
and things like that dazzle the barbarians.

Why don't our distinguished orators come
 forward as usual
to make their speeches, say what they have to say?

Because the barbarians are coming today
and they're bored with rhetoric and public
 speaking.

Why this sudden restlessness, this confusion?
(How serious people's faces have become.)
Why are the streets and squares emptying
 so rapidly,
everyone going home so lost in thought?

Because night has fallen and the barbarians have
 not come.
And some who have just returned from the
 border say
there are no barbarians any longer.

And now, what's going to happen to us without
 barbarians?
They were, those people, a kind of solution.

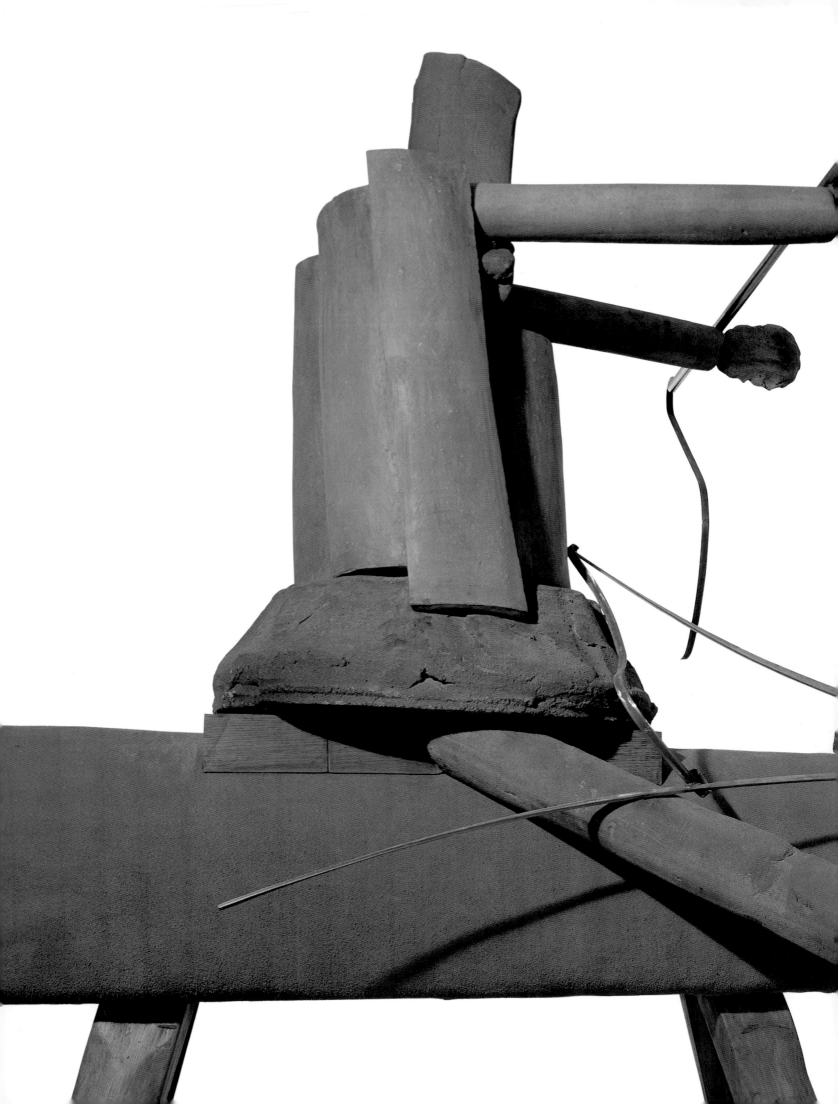

ANTHONY CARO

THE BARBARIANS

Mitchell-Innes & Nash New York

Annely Juda Fine Art London

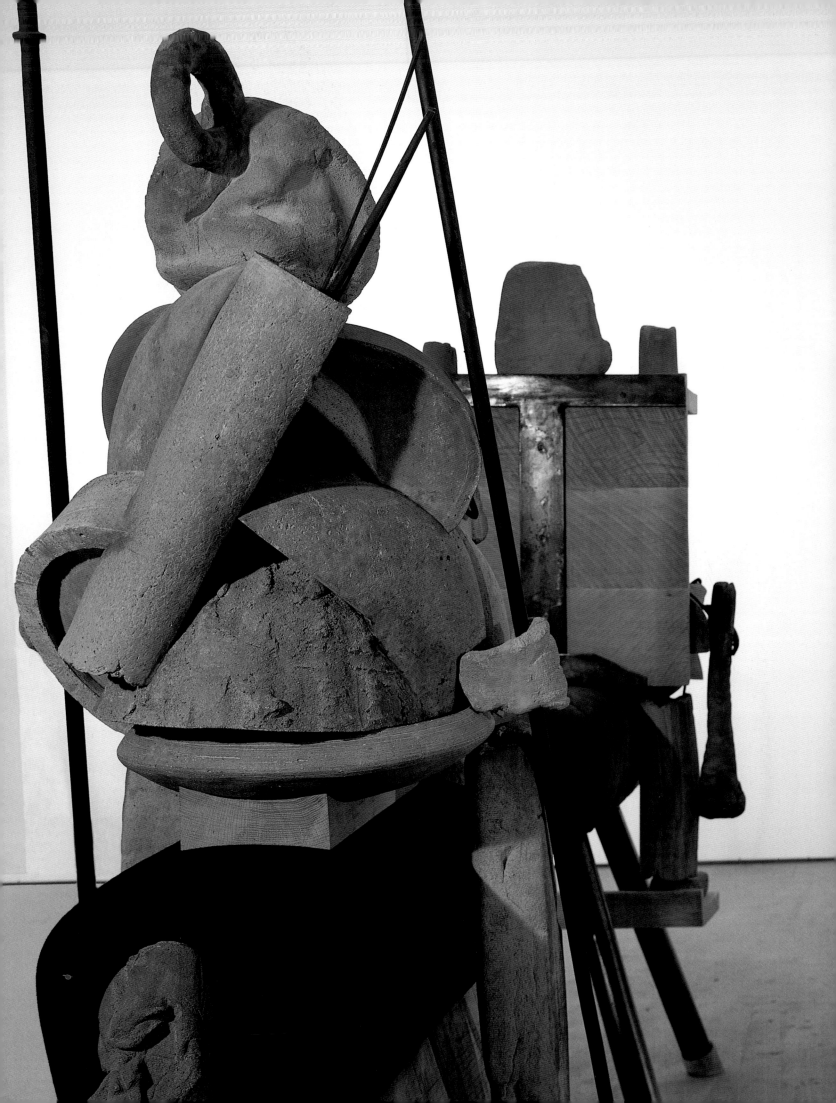

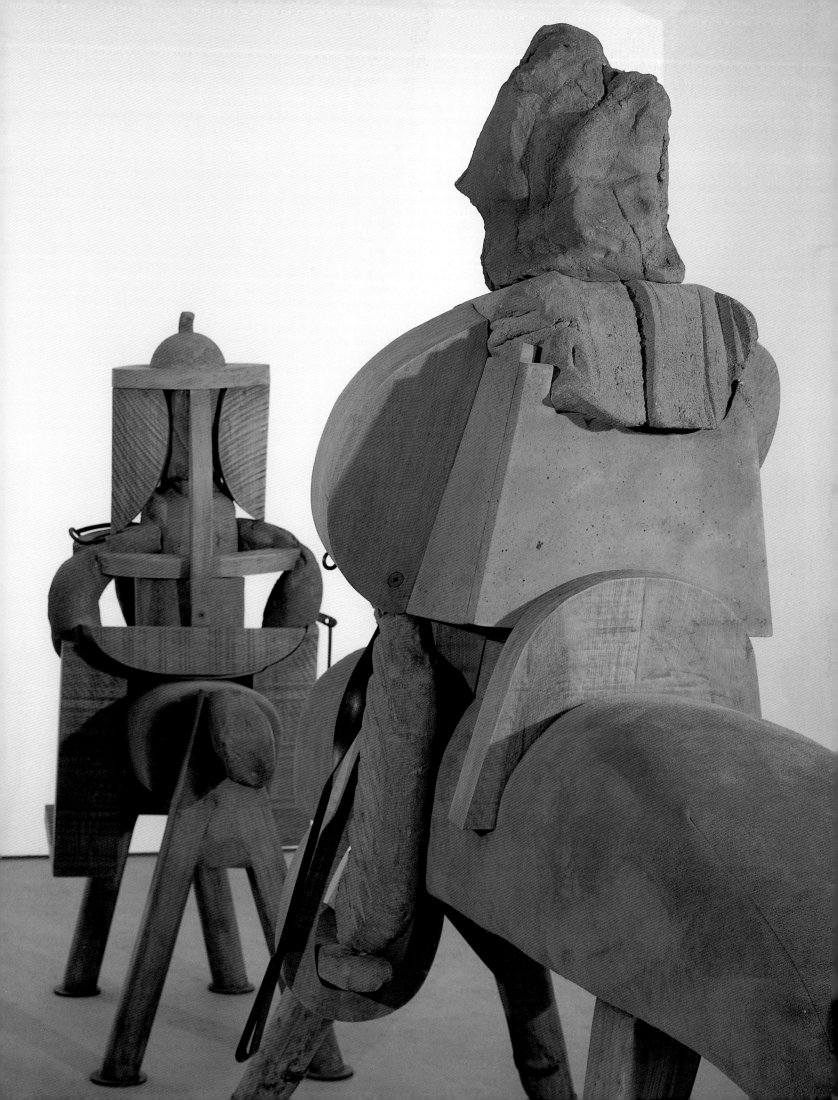

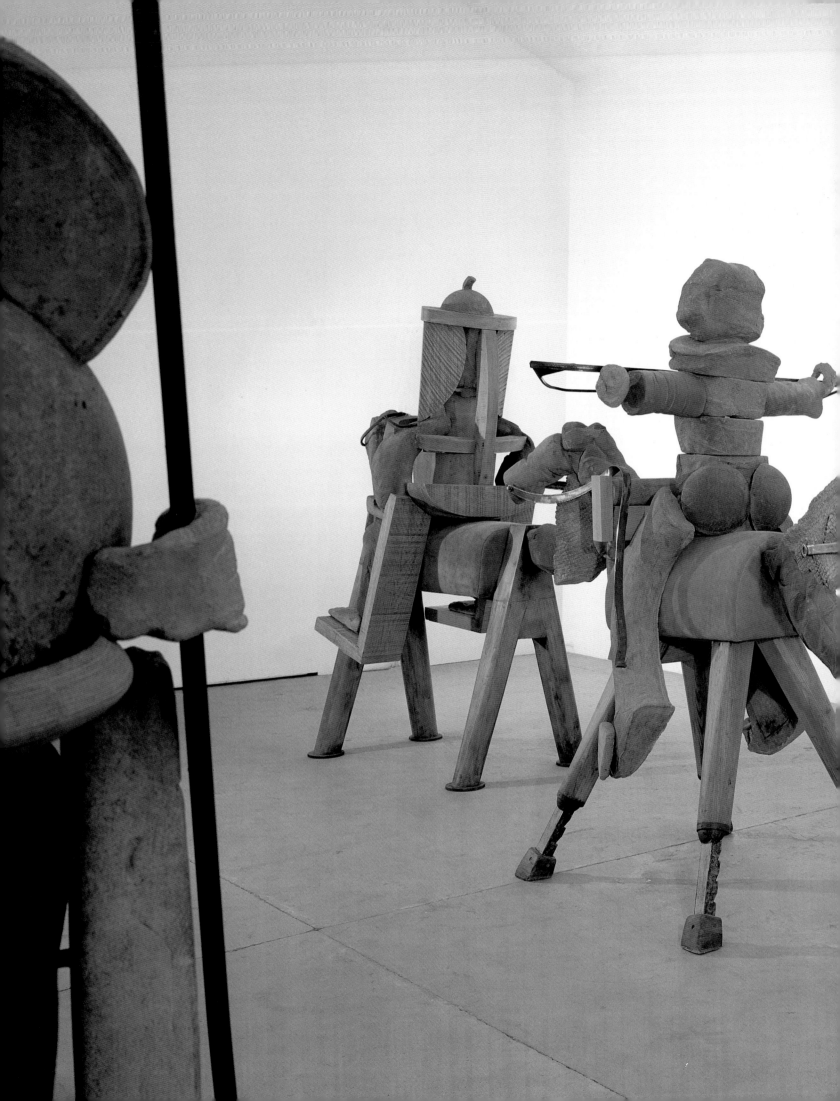

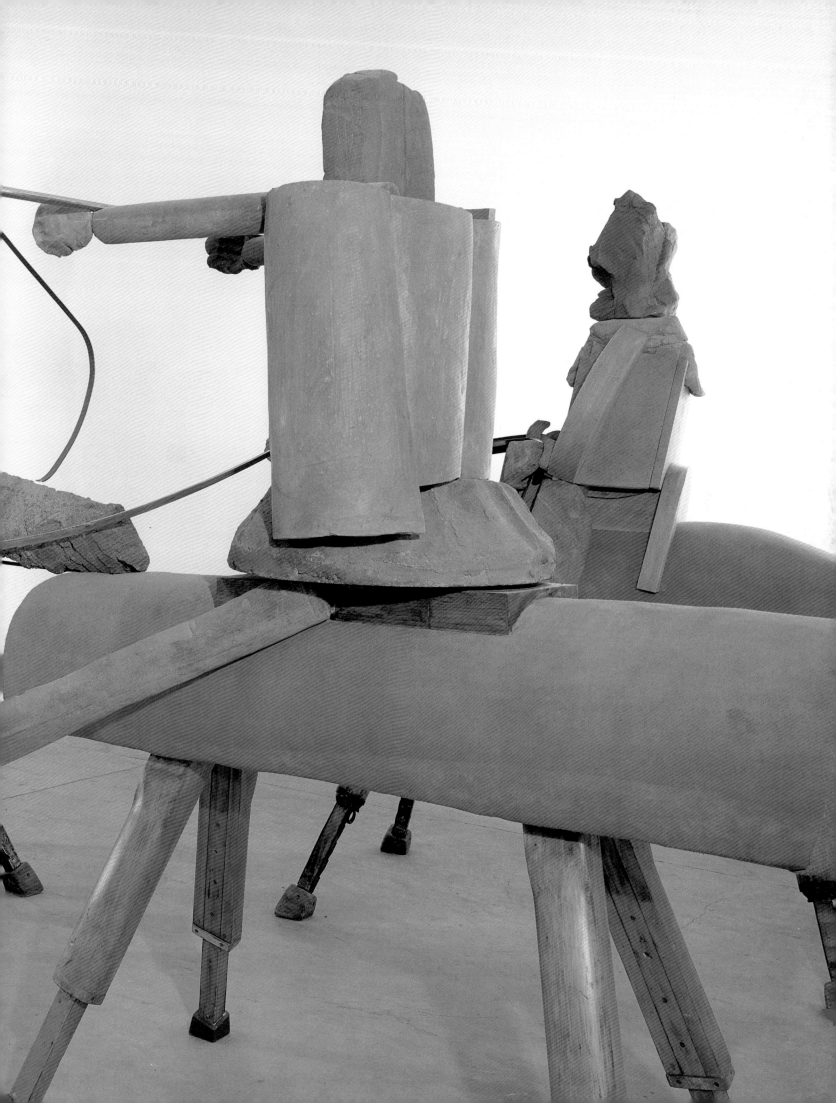

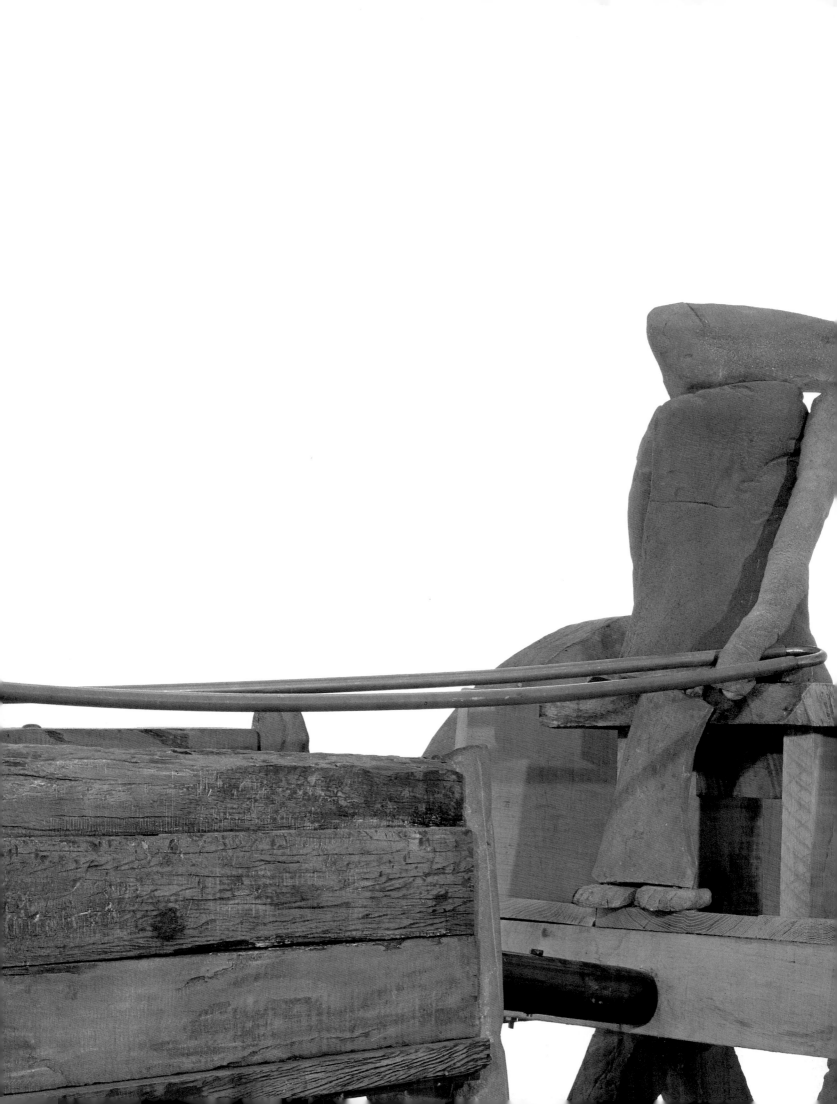

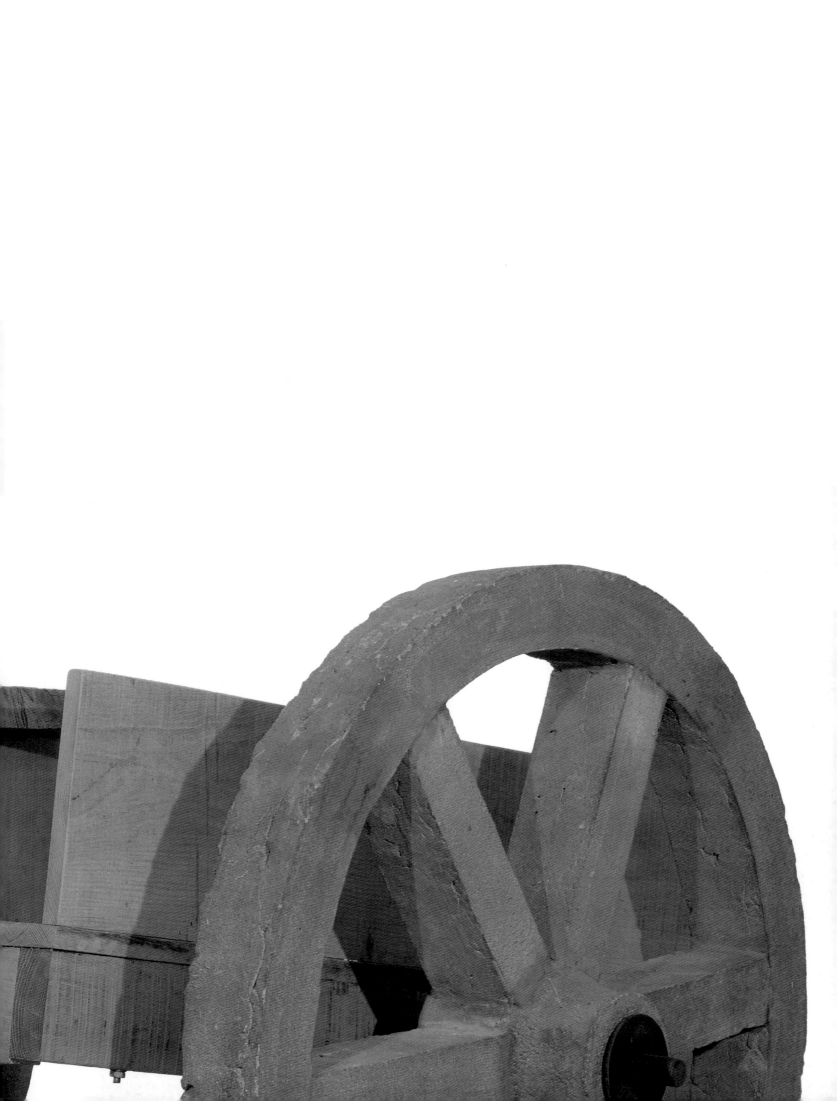

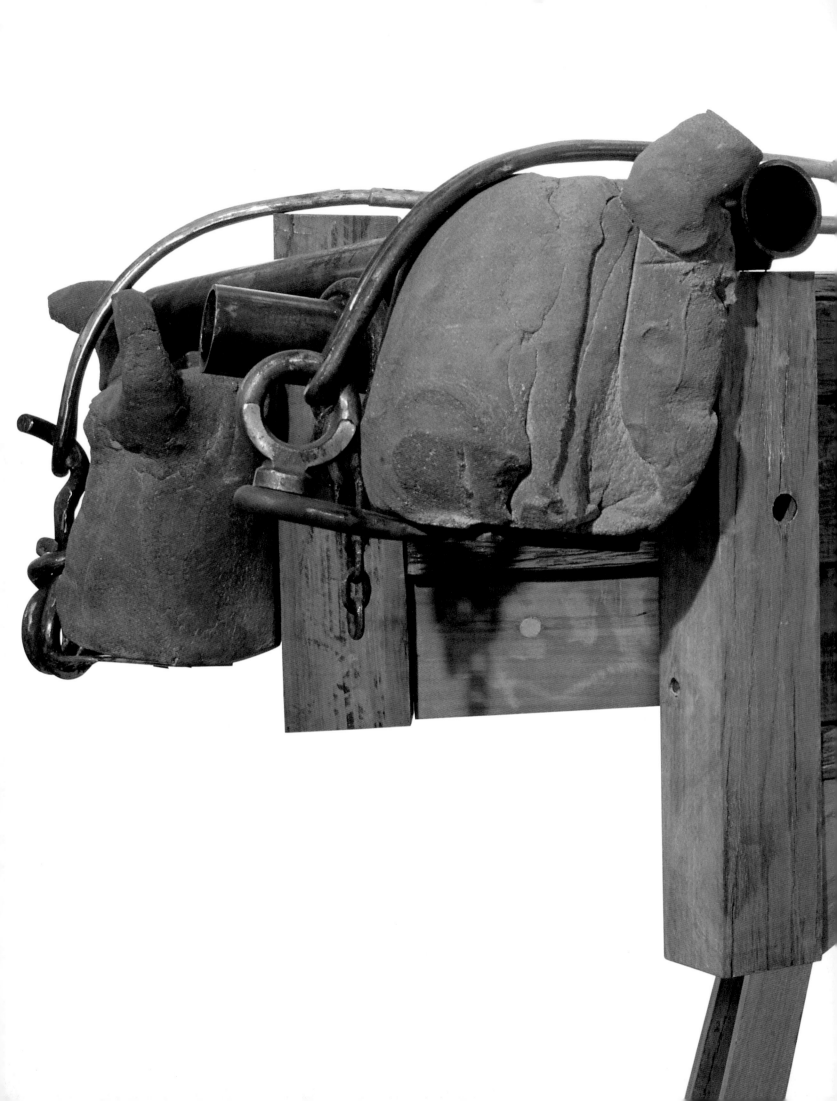

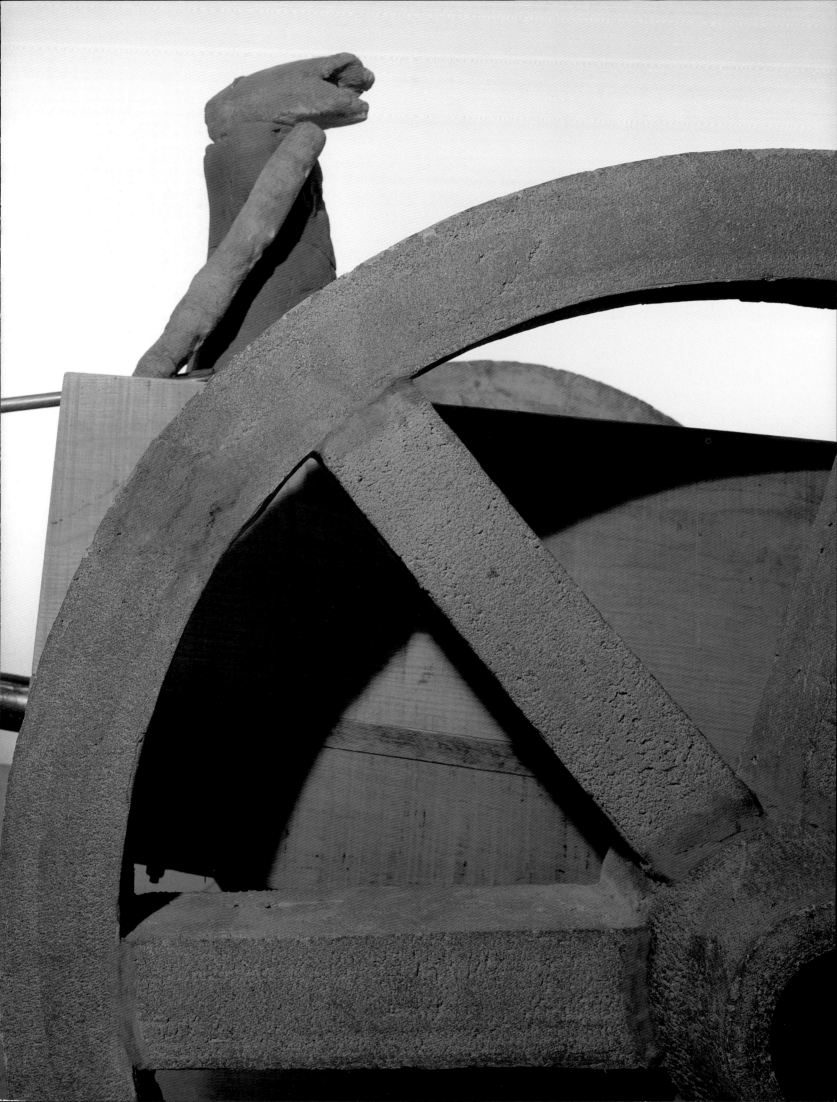

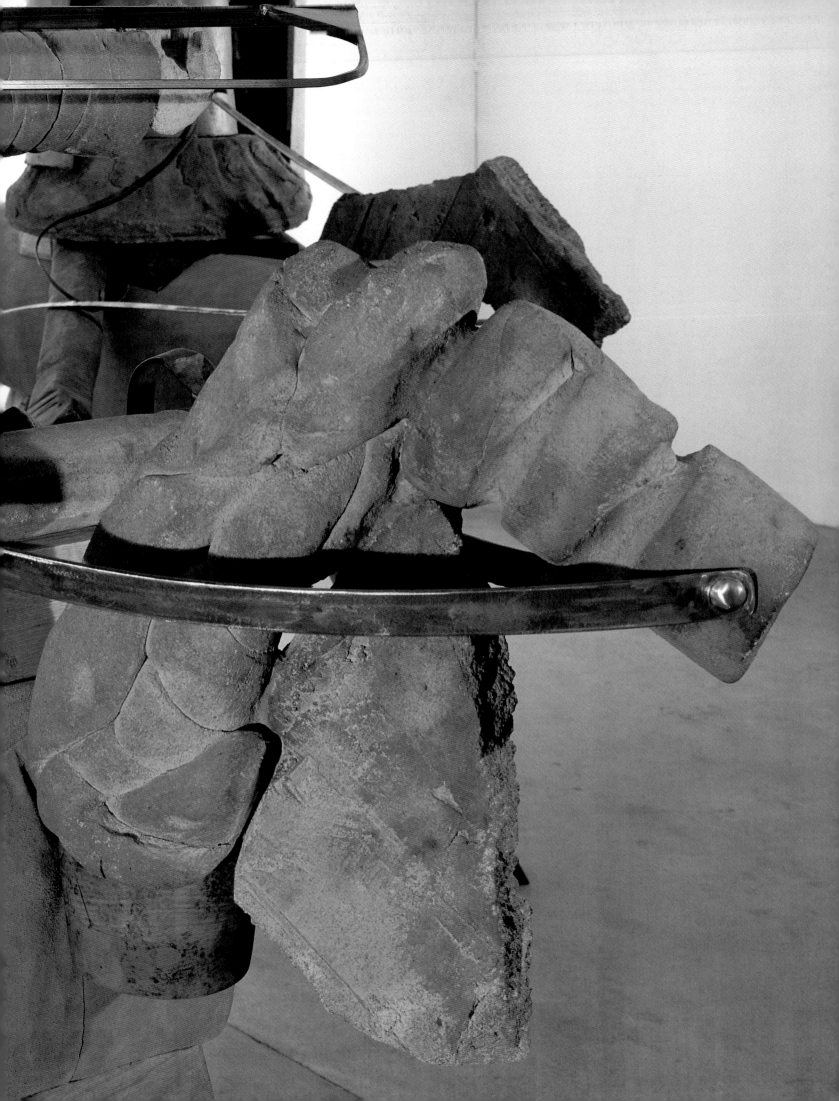

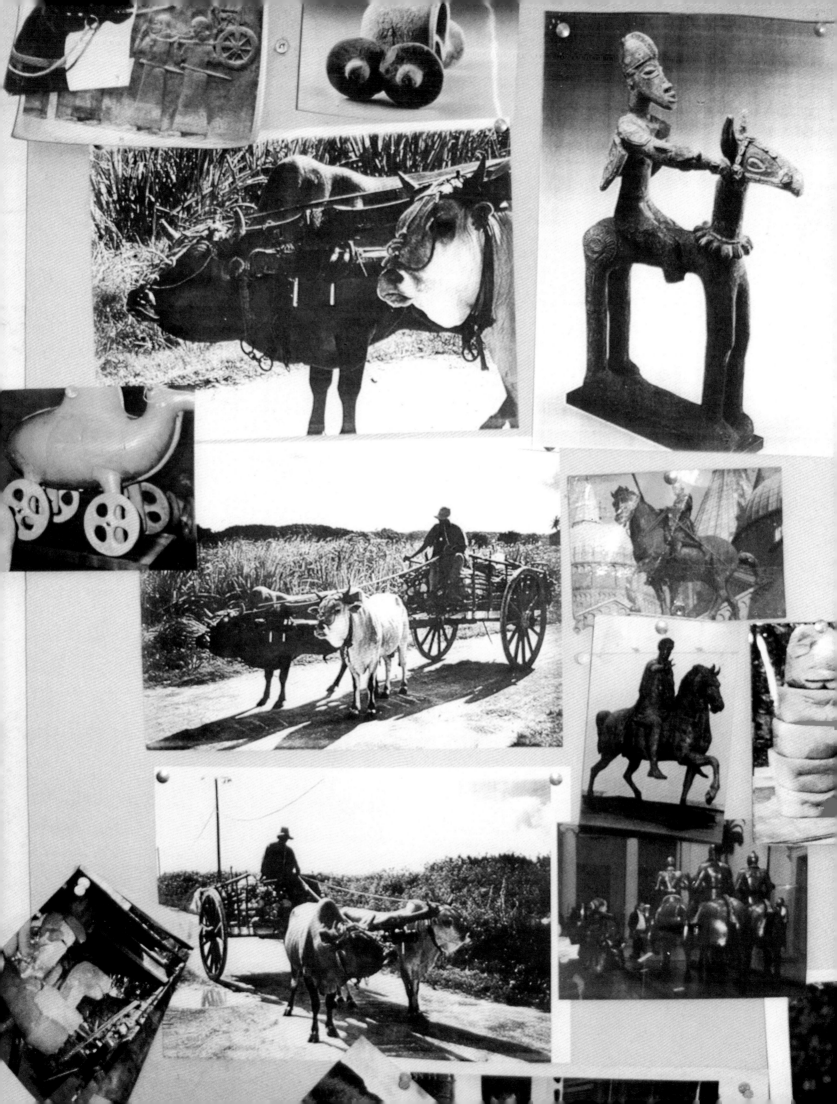

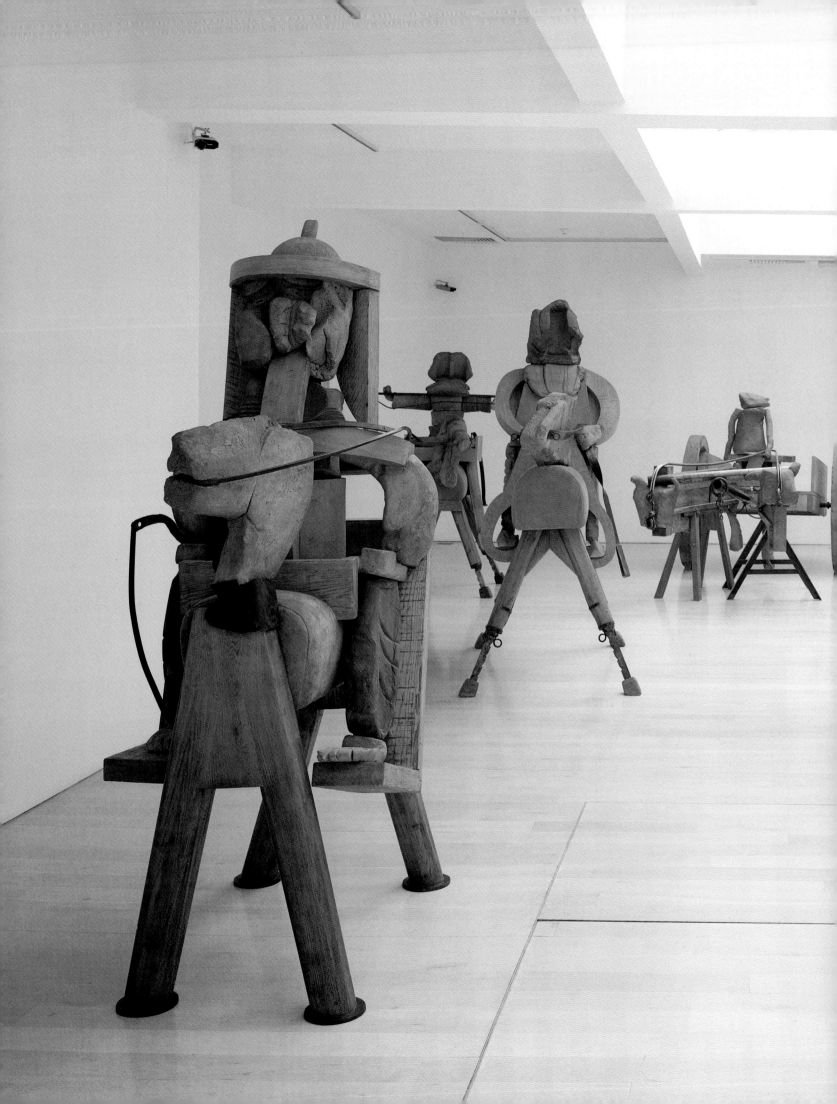

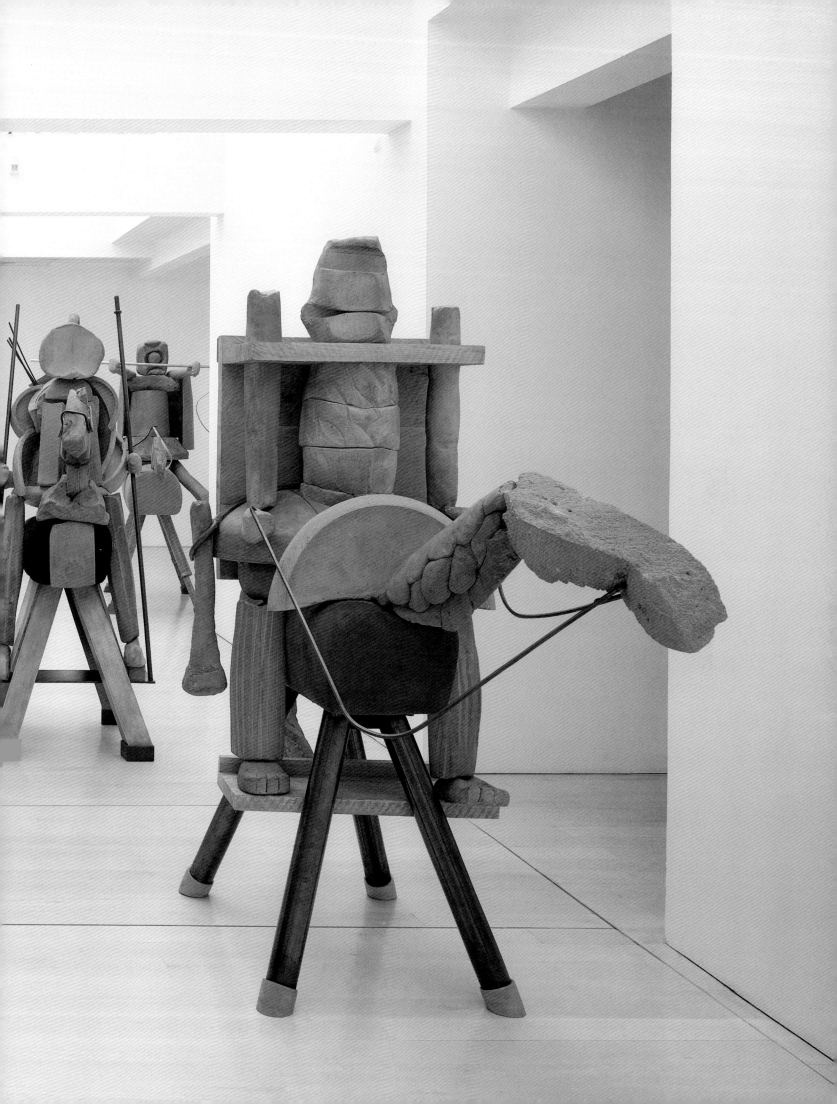

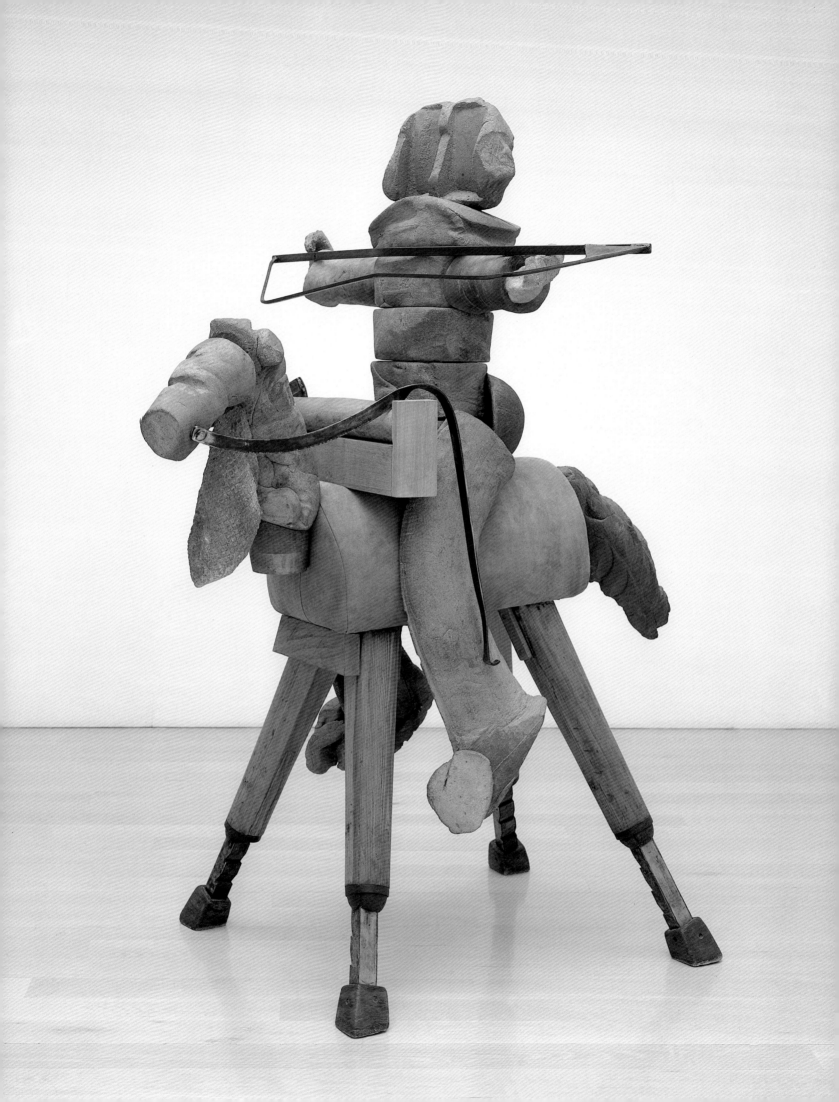

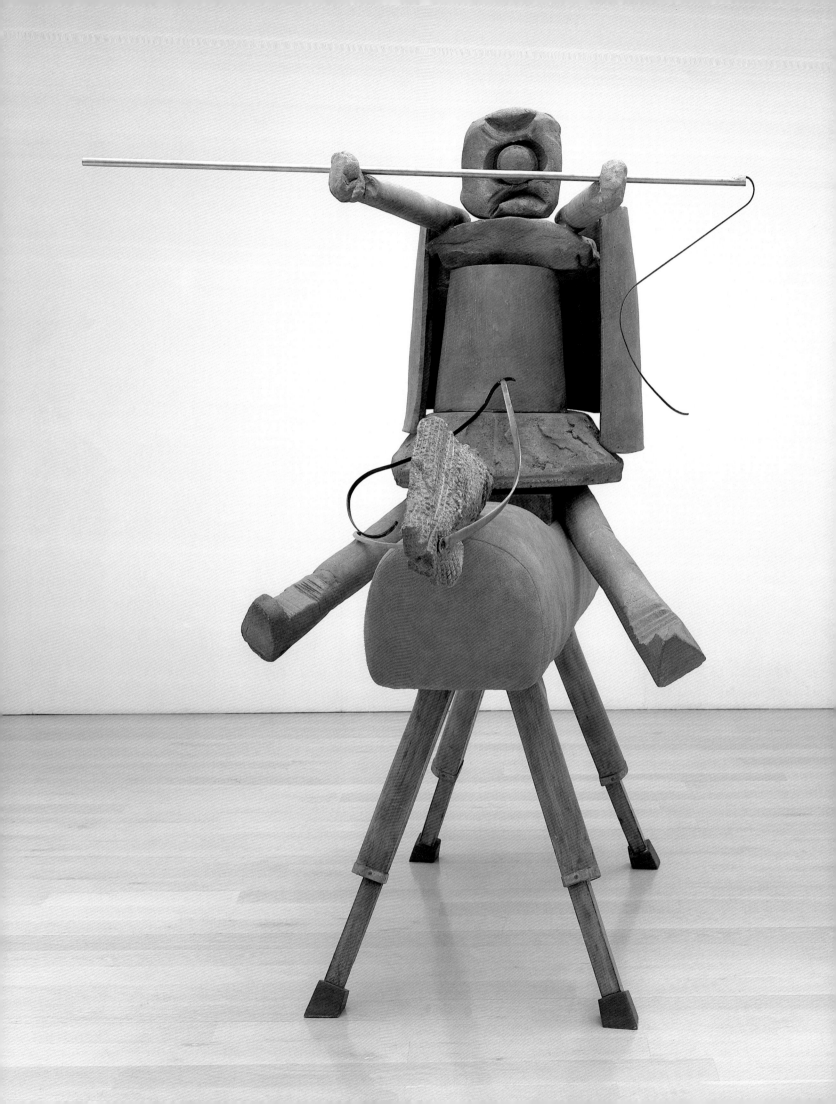

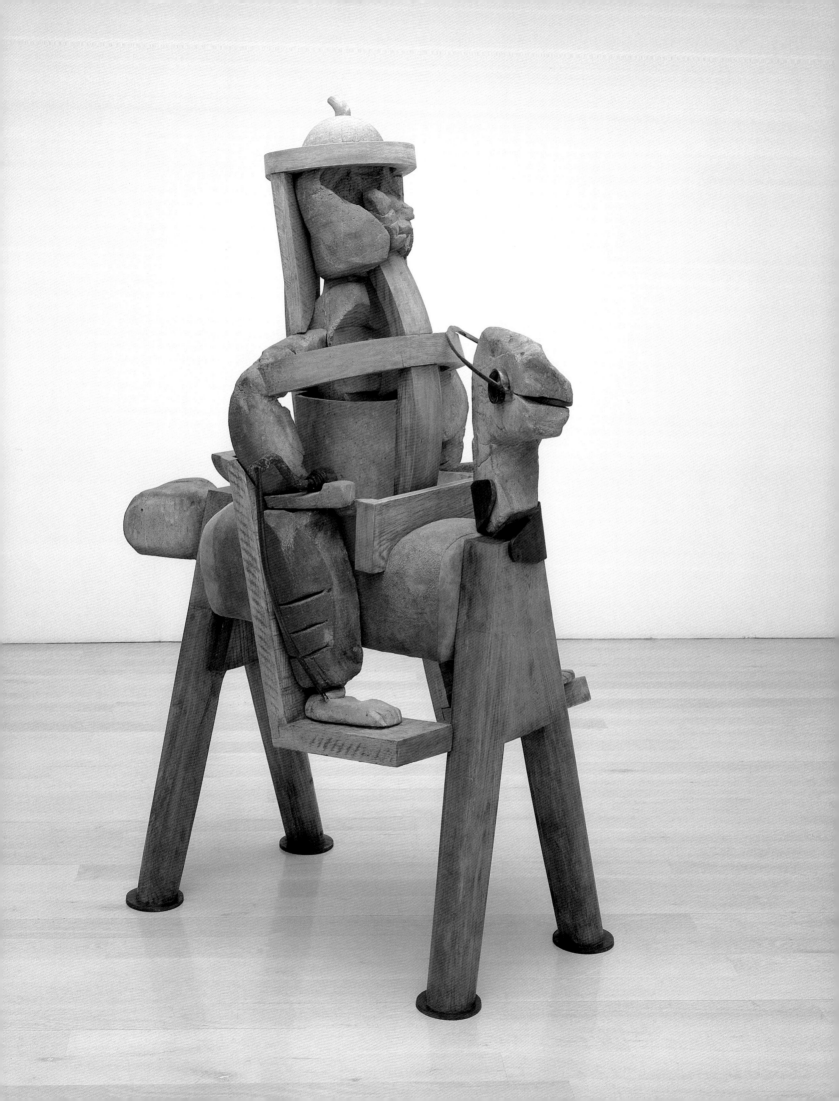

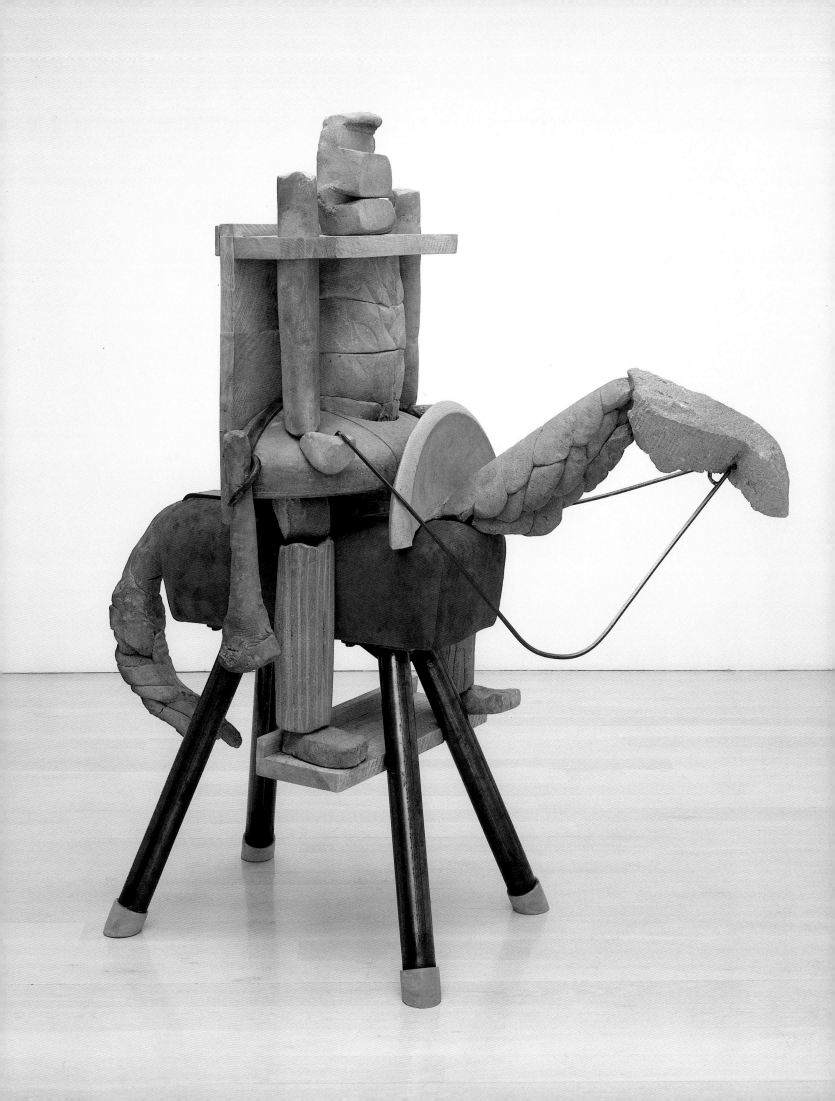

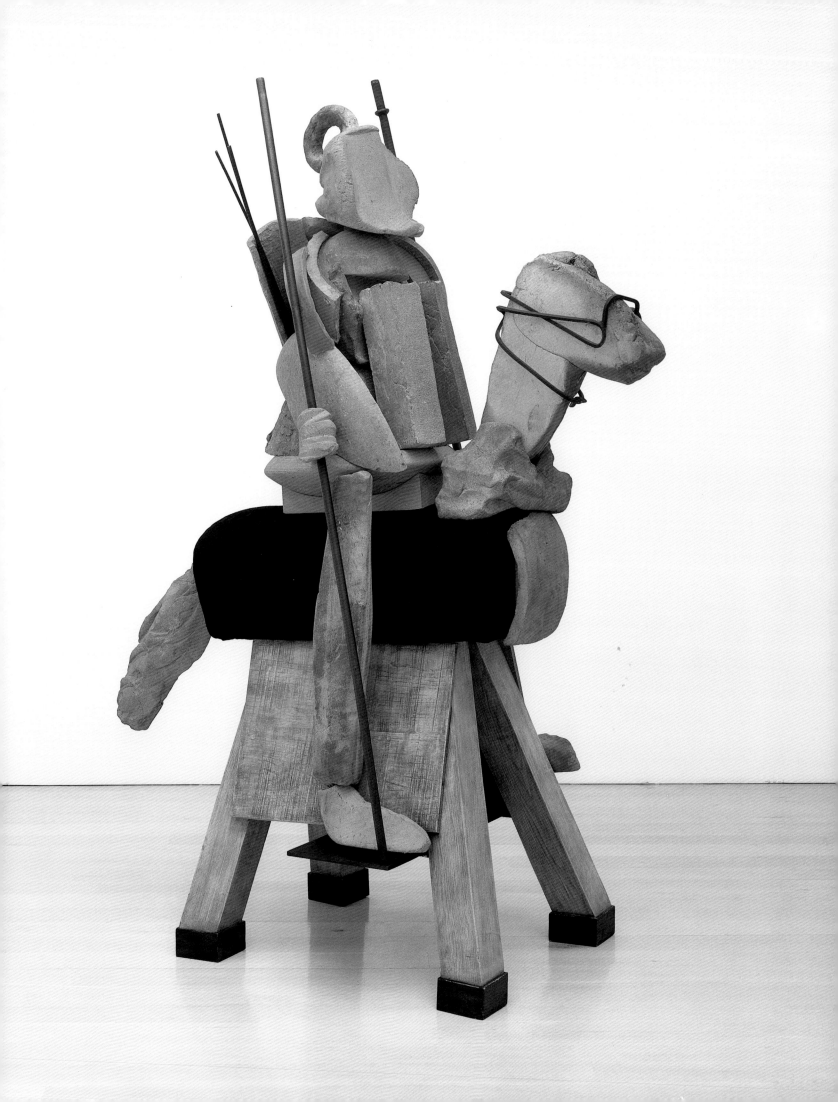

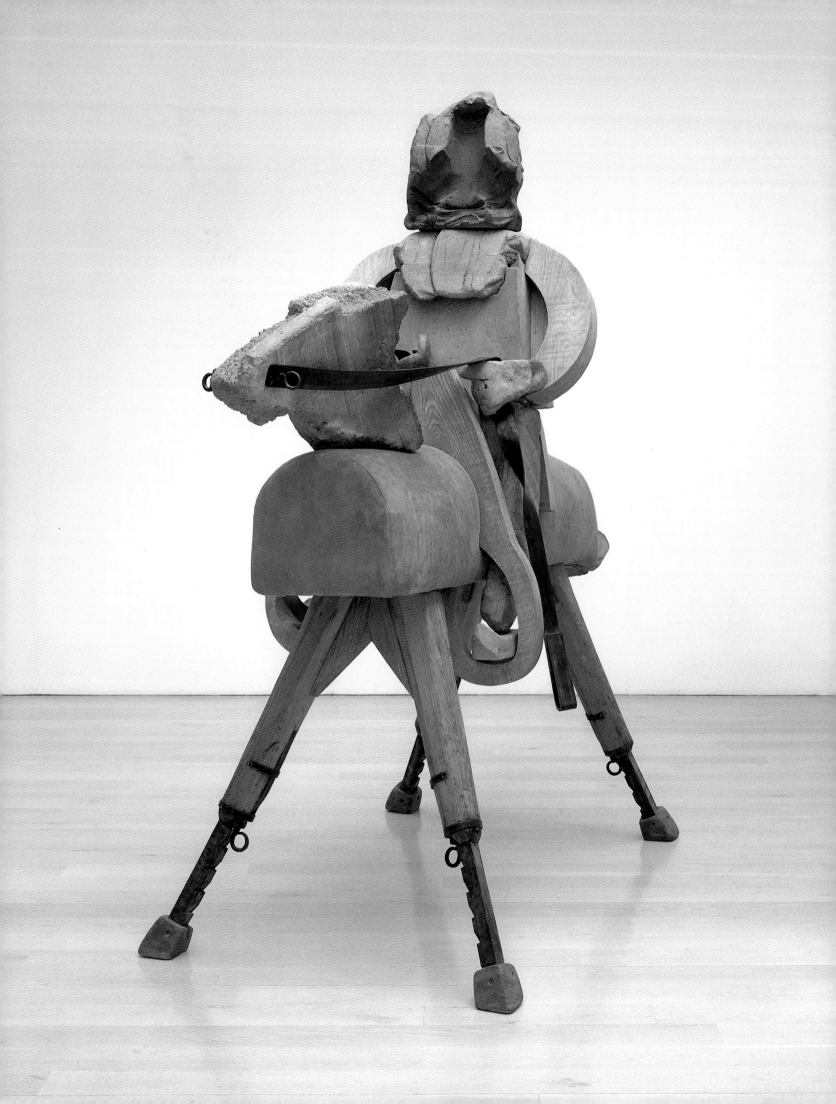

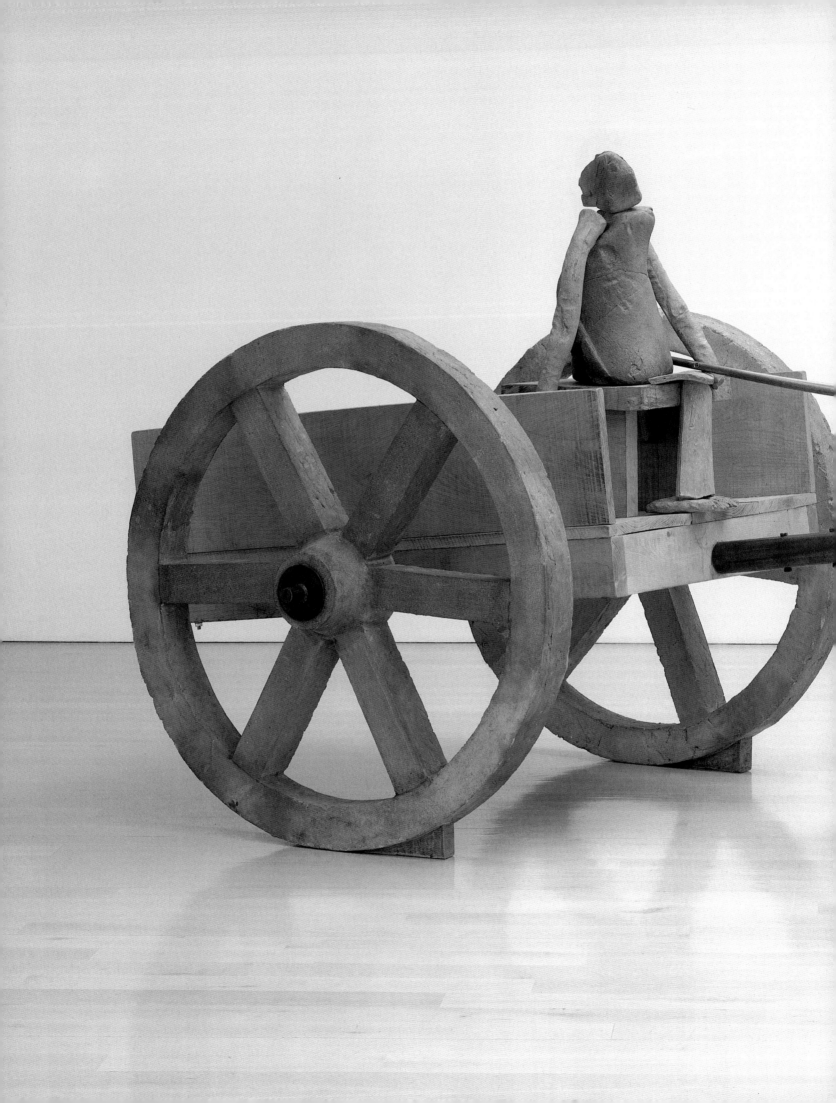

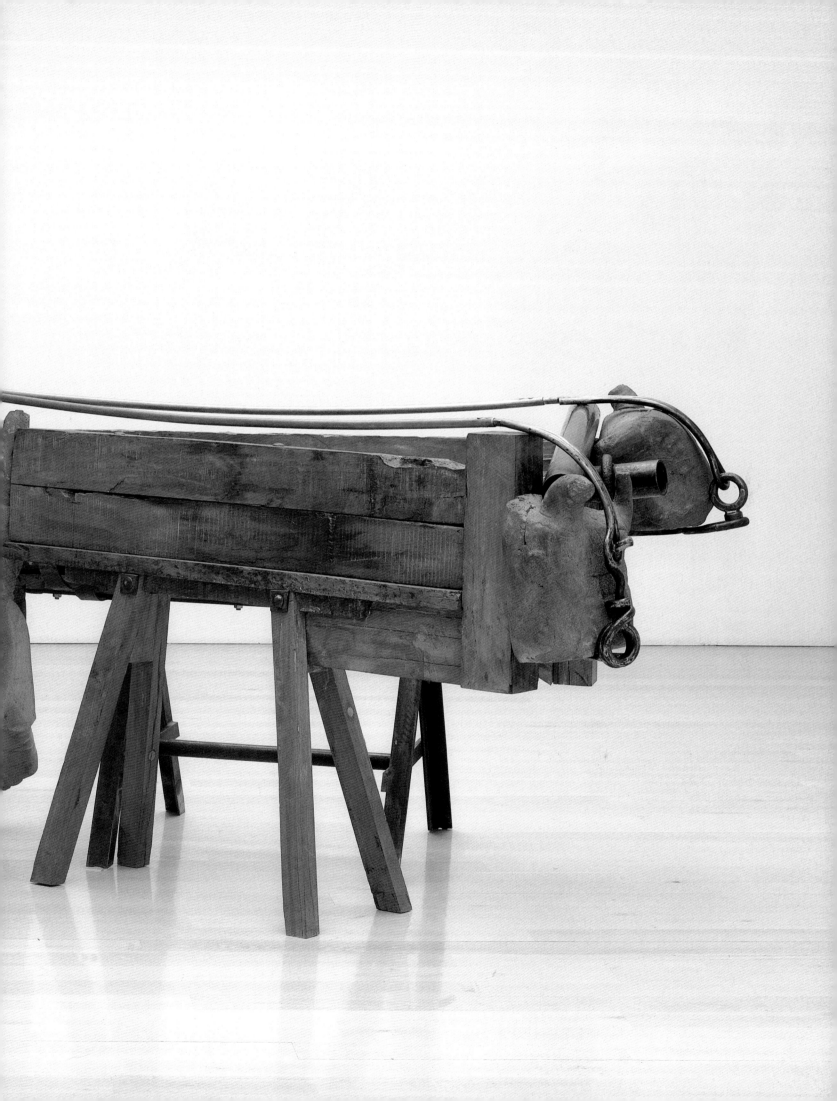

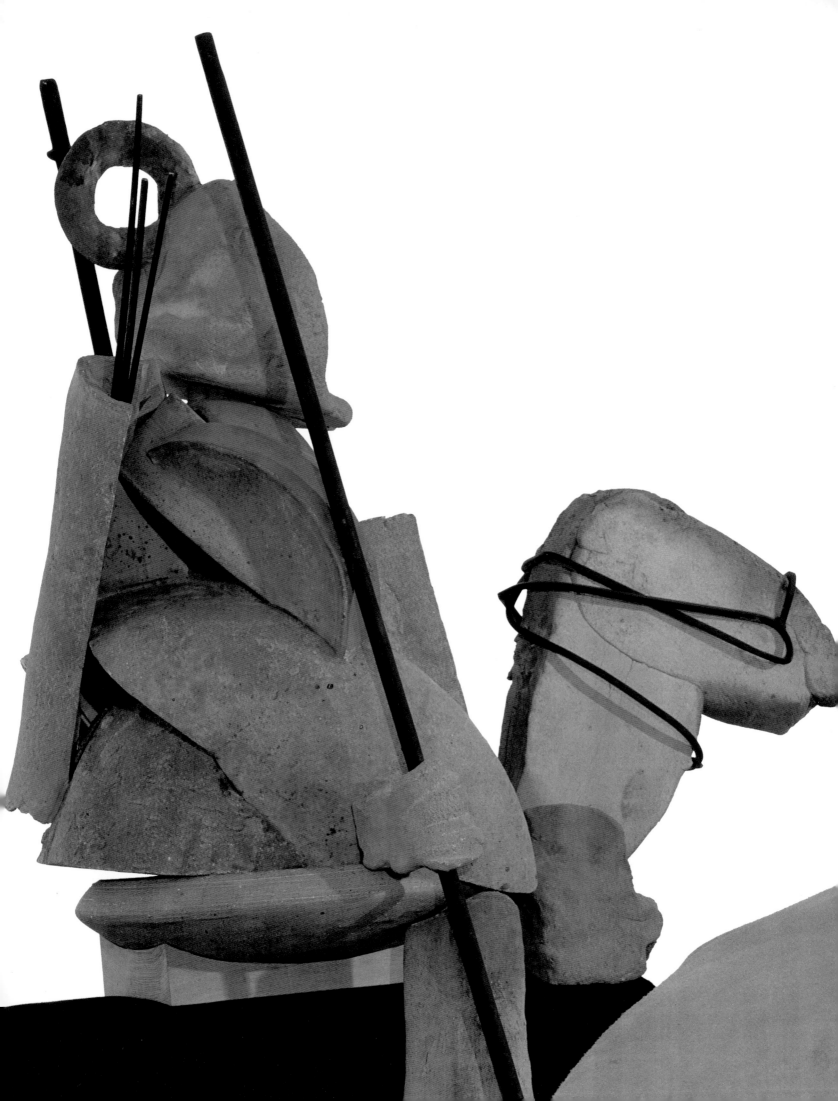

ANTHONY CARO

BARBARIANS
AND THEIR NECESSITY

DAVE HICKEY

The road runs both ways between abstraction and representation. The talent for divining one informs the talent for inventing the other, but we insist on making distinctions. To artists who tease the abstract armature out of the narrative image we attribute the "modernist vision." Those who imagine narratives that vivify this armature we call "romantic visionaries." In this way, we encourage artists to behave appropriately, to do what we want them to do and see what we want them to see. We make false distinctions between different kinds of artists and different kinds of visions. We assign these artists and visions to their appropriate moments. All that really matters, however, is what the artist, who is always looking, is looking *at* when it really counts.

In 1999, Anthony Caro is driving with his wife through Kings Cross in London. They come upon a small cluster of vaulting horses congregated on the sidewalk in front of a junk shop, and Caro, who has spent most of his life teasing the graceful armature out of ragged reality, has a flash of Blakean vision. He looks at the vaulting horses and sees a contingent of rough horsemen in the street—Barbarian marauders reined up in front of a London shop, horses snuffing and clopping, bridles jangling and weapons clanking. Cavafy's famous poem "Waiting for the Barbarians" comes immediately to mind, and the passing Londoners become languid Alexandrians full of fatalism, optimism and dread as they anticipate the

barbarians' onslaught. The vision seems peculiarly appropriate to the millennial moment, as does the implied subject of Cavafy's poem, which is the *necessity* of barbarians—the creative possibilities of their destabilizing impact. It is not difficult, then, to fathom the appeal of this concept to an artist of Caro's stature and maturity. Nor is it difficult to imagine the sweet prospect of presenting oneself once again as a rough barbarian in an age when artists signify their disaffection with feigned weakness and theatrical abjection.

In any case, Caro finds his vision of horsemen strange enough, rich enough with intimations of prophecy and nostalgia, to purchase the vaulting horses that provided its occasion, and with the purchase of these talismanic armatures the entire history of equestrian sculpture comes into play. The pin-board above the artist's worktable is soon crowded with images of horses, horsemen and charioteers, Sumarian, Egyptian and Chinese, Renaissance mercenaries, Medieval knights, Huns, Goths, Tartars and Mongols. The mature barbarian, of course, needn't be an ignorant Philistine. Nor does the mature sculptor have any need of revising his evolved methodology. Like virtually all of Caro's sculpture, his seven "Barbarians," are *put together*, assembled from fabricated parts into complex, essentially monochrome units.

The individual figures are built upon the vaulting horses, each modified for the occasion and elaborated by elements of wood and steel and clay. The wood and steel is cut to fit but not modeled or refined. The clay units have been made by Caro in the south of France with ceramicist Hans Spinner, not for specific figures but as a repertoire of parts, of heads, legs, torsos and arms to be mixed and matched in the studio—an apt metaphor for the genetic diversity of nomadic peoples—and here, as in all Caro's work, the sculptural assumption is that the artist *connects* things and puts them together. He doesn't refine them by cutting parts away and paring them down. This was the traditional manner of Caro's great teacher, Henry Moore, and, for Caro, the materials of art are presumed to be available in the world not hiding in the stone or in the clay or in the domain of metaphysical certainty. The parts require inspired assembly, nothing more, and demand to be assembled in a way that grants each of them some semblance of their original physical autonomy.

Caro's procedures, then, derive from a tradition of assemblage with roots in Constructivism and the Bauhaus. Even in these new figurative works, Caro is always more concerned with the physical integrity of the parts he assembles than with the found narratives that these parts might bring with them. These found narratives, of course, obsessively beguiled assemblageurs like Picasso, Man Ray and Rauschenberg whose works they invest with the twentieth century equivalent of sculpture's traditional literary miasma. In Caro's

new work, the absence of this "found meaning" and any semblance of "discovered form" that we accept in his abstract work, places the figures he has created in an extremely anxious relationship to the traditional objects they insistently evoke.

It could be said, I suppose, that Caro's figures, like those of Henry Moore, seek to assert their historical continuity with the past. The problem with this is that Caro's work, while alluding to the configuration of the past, willfully repudiates the tradition of tribal craft and carving in which Moore so comfortably immersed himself. This historical abyss is further widened by the fact that Caro has rigorously resisted the impulse to make these antique shapes look old. There is no "patina" or anything like it, so despite their primitivist cast and historical allusions, these new barbarians *look new* and are clearly intended to. As a consequence, their reference to the past seems less a homage to ancient practice than a poetic trope along the lines of Cavafy's, and, in point of fact, if Caro's "Barbarians" may be said to maintain a live relationship to any sculpture other than Caro's own, it is almost certainly with the constructivist figuration of Joel Shapiro, whose work, like Caro's, tells the story at one remove as the sum of the work's visible parts.

The point to be drawn here, I think, is that Caro's are clearly and willfully *modern* barbarians not folk craft simulacra. They are *built* barbarians, rough creatures of the pallid present, and to grasp the full inference of their willful currency, simply imagine for a moment that you are confronting these works under the mistaken impression that they were created by a twenty-five year old. If you can conjure up the surprise and delight, the sense of promise and possibility that would inform these figures, thus misapprehended, you will touch them in their historical moment and begin to realize just how assiduously we conspire to deny adult artists both the privileges of maturity and the permissions of youth. Without quite admitting it, we expect artists to romance their youthful sweethearts ever and anon— to proceed steadily onward through the mist of youthful dreams.

The artist's mature desire to expand the breadth of his or her practice, to look back into the historical depths of its long inheritance, seems to us a betrayal of that original romance—a divorce from that first sweetheart whom we loved as well. At the same time, the artist's youthful zest for surprising and outraging us—the very instinct that amazed us at the outset—seems to us after that first surprise to constitute a kind of barbaric impudence. How dare they surprise us *again*! Underlying this prejudice is the modernist habit of imagining culture moving in one direction, as on a single track from barbarism to utopia, from youth to maturity—of imagining artists moving similarly along the track of their careers. The fact that we no longer credit this trope does nothing to deter our embrace of

its vestigial, historicist assumptions. And the fact that no artist of Anthony Caro's stature has ever come close to conforming to these developmental assumptions, does not keep us from imagining that artists do.

It is true, of course, that by devoting the first quarter century of his career to the multifarious options of fabricated abstract sculpture, Caro may have lulled us into the expectation of "development." But twenty-five years is not a long time to spend on a group of ideas about large, hard sculpture. It is no time at all, in fact, when you remember that, by dispensing with the narrative and psychological agendas of early modernism, Caro virtually reinvents the genre, and that, as a consequence of this reinvention, Caro's work languished only momentarily in obscurity. For all intents and purposes, Caro's work has never not been known, although it has not always been known that well. In fact, Caro's practice has been routinely recruited in support of agendas not its own, then ritually damned by its association with these agendas when they fall from favor.

To cite the obvious instance, we should remember that in the very moment of its initial triumph and at the dawn of sculpture's new ascendancy, Caro's work is recruited to support an argument about the primacy of *painting*! Caro is said to have finally and efficiently dispensed with the sculptural base in favor of a painter's resolution of forms in space. In retrospect, of course, it seems clear that, rather than dispensing with the base, Caro dispenses with the narrative object that the base traditionally supports. In fact, he *apotheosizes* the base in works obsessively concerned with sculptural solutions to the problem of getting the object onto the ground without becoming a part of it. Caro's solution to this problem is, first, to paint the work in industrial monochromes that distinguish the sculpture from its site and, second, to take the work aloft on multi-point supports.

In doing this, Caro creates objects whose chromatic dissonance with the site combines with their apparent lightness and spring to imply a condition of ludic mobility, an aura of good-natured imposture. As a consequence, Caro's objects do not so much inhabit the world as furnish it, and this institutes a primary shift in modern sculpture's domain of mimetic reference. In the same sense that poems present themselves as mimetic speech and pictures present themselves as mimetic windows, sculptures before Caro, from Michelangelo to Brancusi, traditionally presented themselves to us as mimetic "creatures" of one sort or another. Caro's work, by combining domestic reference with industrial facture, activates a whole new field of mimetic reference—the table, the bench, the chaise, objects primarily concerned with "getting onto the ground." In this way Caro creates a new

genre of non-utilitarian objects whose theatricality derives from their subliminal reference to utilitarian forms.

Early on, Donald Judd transforms Caro's idea of sculpture as ideational furniture into his own idea of sculpture as minimized furniture, then, ultimately, takes the logic full circle by applying that reductive rigor to a line of designer chairs. Scott Burton spins Caro's idea off into a practice in which the utilitarian function of the chair becomes the single constant in a sculptural endeavor that explores the permutations of "chairness" through a cacophony of forms and styles. Richard Serra transforms Caro's idea of sculpture as its own support into a kinesthetic assault on the earth itself. In his own practice, Caro is never tempted by reductive ideology, blatant utility or any other unintended consequence of his own innovation. The straightforward idea of self-sufficient sculpture that incorporates its own support provides him with twenty years of options.

This endeavor culminates in 1987 with "After Olympia"—the ultimate piece of sculptural furniture—a giant's banquet-table laden with a heavy feast of ominously appetizing steel. With this piece, I have always felt, Caro's work touches the edges of sculpture's domain. The work moves in one direction toward the pictoriality of a giant Dutch still life and in the other toward the hard monumentality of architecture, as the weight of the steel bears down upon the table's support as a city upon its foundations. Taking this cue, Caro moves on to explore both the pictorial and architectural edges of his practice for the next decade, finally arriving, improbably, by the serene backward logic of artistic exploration, at a point just before he began.

The Barbarians may be said to occupy this position, and, over and above the cultural commentary they provide, we may take them, I think, as a rough-hewn, pictorial explanation of Caro's primary innovation. Simply drawn, as if for children, they tell us this: The artist began with tables, with the lightness and implied mobility of their multi-point support; the table, however, is just a stationary horse, and the horse is man's first, ideal support, his primitive icon of stability and mobility. Thus, in one way or another Anthony Caro has always been making equestrian sculpture—appropriating its subliminal narrative of freedom, athletic grace and barbaric ambition to his own purposes. He will probably continue to, and this seems to me to be a very good idea.

Dave Hickey
2002

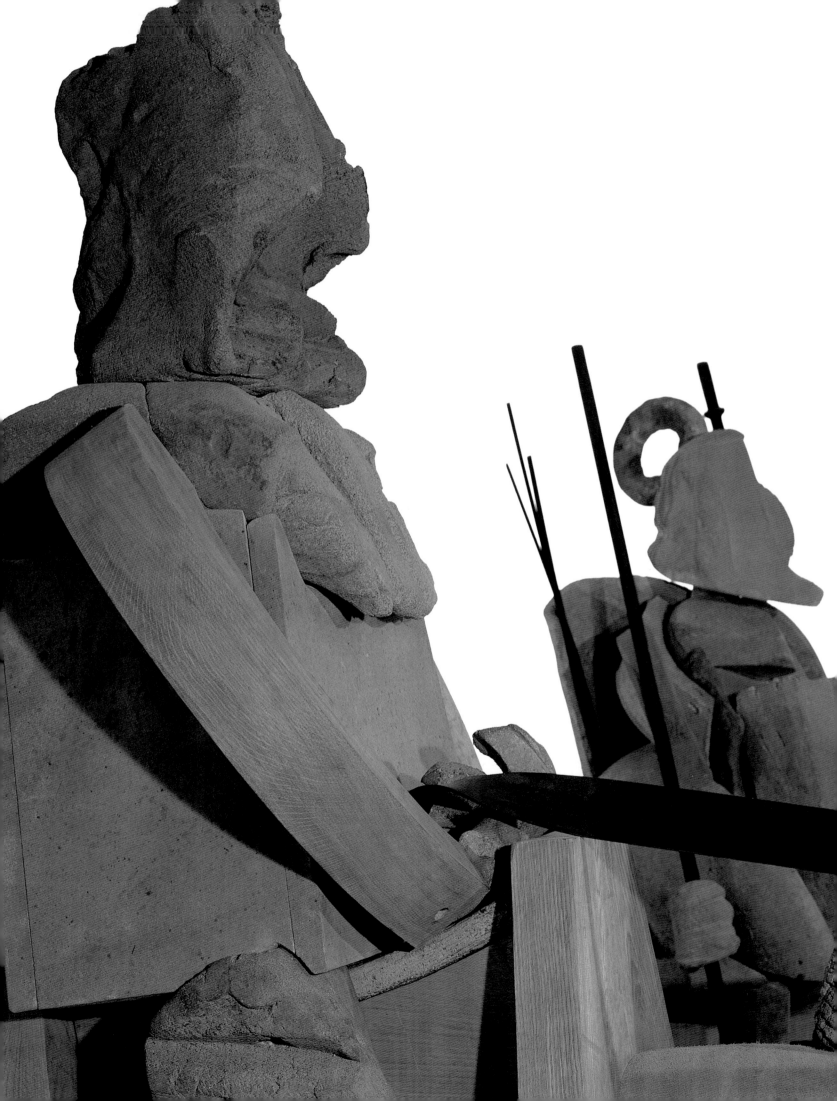

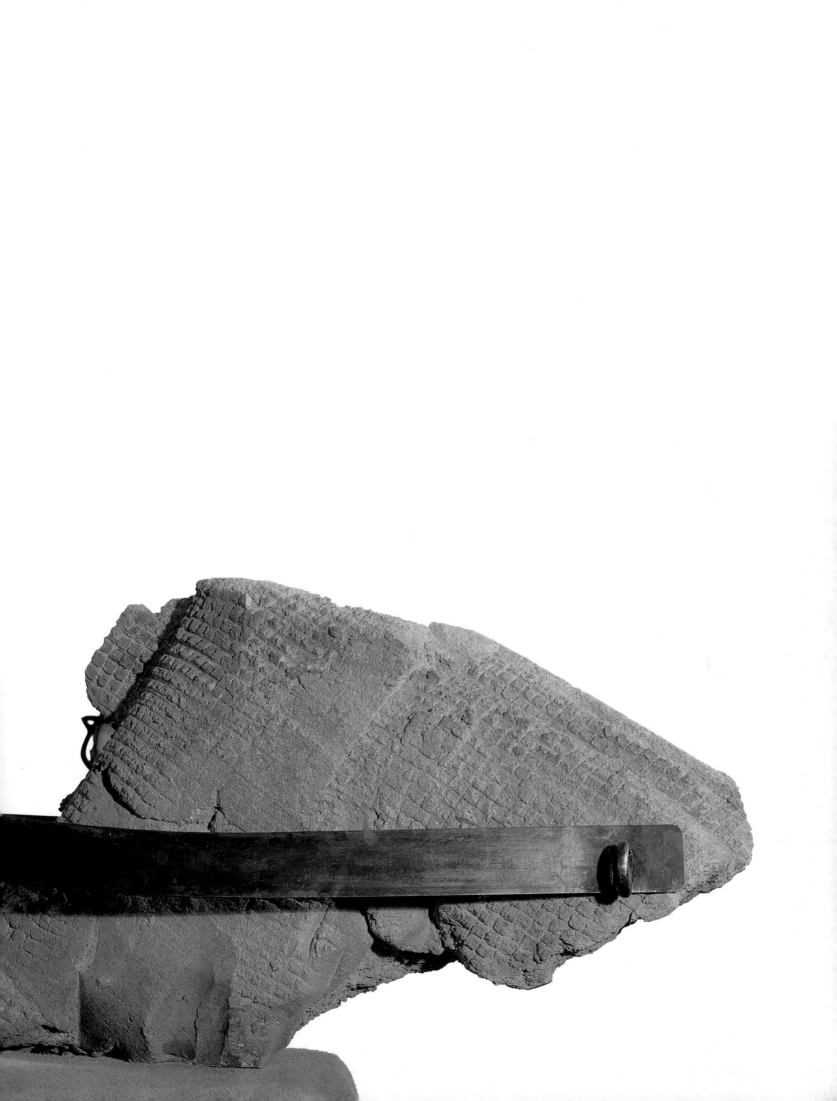

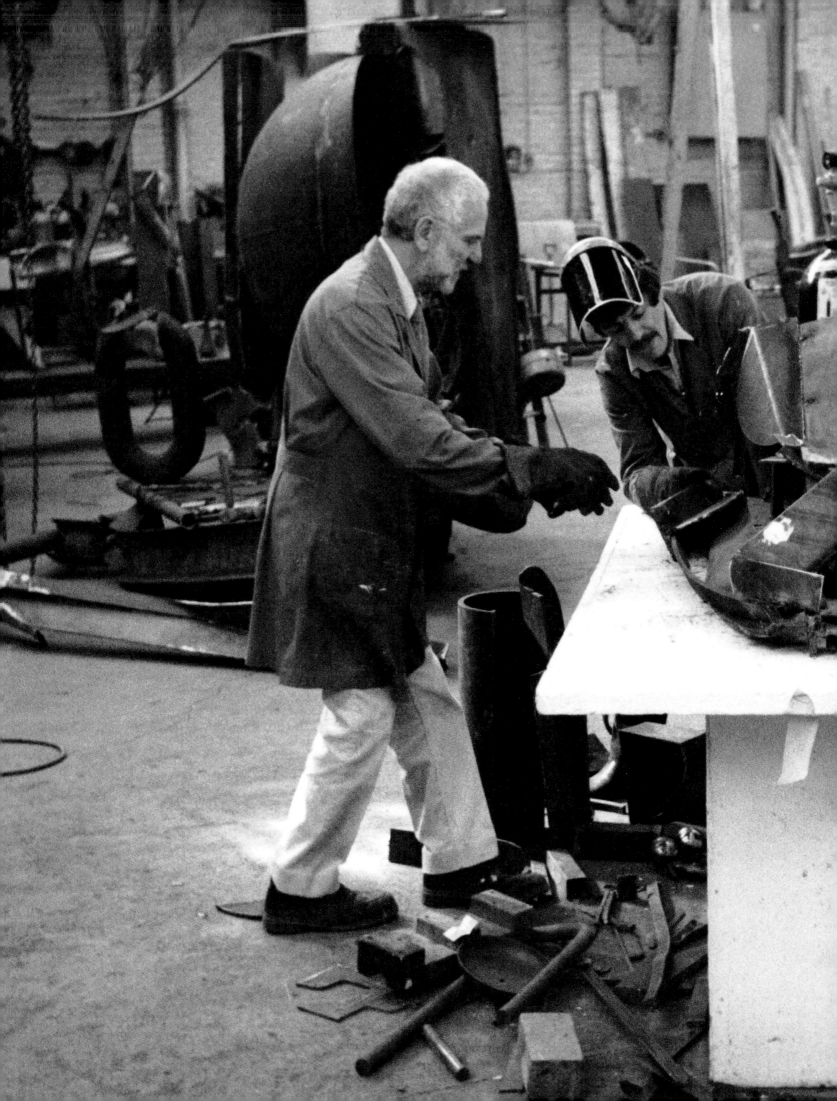

"What are we waiting for, assembled in the forum?
The barbarians are due here today"

"....And now, what's going to happen to us without
 barbarians?
They were, those people, a kind of solution"

Constantine P. Cavafy
From *Waiting for the Barbarians*

Mitchell-Innes & Nash and Annely Juda Fine Art are delighted to present "The Barbarians," Anthony Caro's most recent and exciting body of work.

Annely, David and I have known Tony for many years. It is a particular honor and privilege for me to show his work in New York, not least because it was Tony who gave me my first job after completing my studies at the Courtauld Institute in London. This was long before I had any plans of having a gallery of my own, let alone one in New York. Annely and David have regularly shown Tony's work in their gallery in London since the late eighties and have worked with him on many projects including the exhibition of the "Last Judgement" at the Venice Biennale in 1999 and "The Trojan War" from 1993-94 which was exhibited worldwide.

Tony has been working on the Barbarians since 1999 following his inspired purchase of some vaulting horses from a junk-shop near Kings Cross station in London, but the concept reaches back much further. It is a summation of many themes and ideas spanning a fifty year career: the early figurative works of the 1950s, the table pieces of the 1970s, Tony's experimentation with other mediums such as clay and ceramic in the 1980s, his interest in architecture in the 1990s and most recently his return to more figurative and narrative works. The group encompasses his curiosity for other cultures, his love of poetry and literature, history and classical antiquity. And yet the Barbarians are something totally new in Tony's oeuvre and that is why we are so excited to present this particular body of work to the public on both sides of the Atlantic.

America has always held a special significance for Tony; he first came to the States in 1959 where he met artists such as Kenneth Noland, Jules Olitski, Helen Frankenthaler, Robert Motherwell and of course David Smith, all of whom had a profound influence on his work which thereafter underwent a major breakthrough. Since then he has maintained strong associations with the United States and we look forward to nurturing these bonds. Having reached a time in life when most people start slowing down, Tony is tireless in his quest for new experiences and ideas and indeed the next few years are going to be even busier for him—in October 2002 there is an important survey exhibition in La Pedrera in Barcelona and at the same time in an adjacent building the famous "Last Judgement" will be shown. In 2004 a major retrospective will open in London at the Tate Britain.

Many people have played a vital role in putting together this exhibition, but first and foremost, we would like to thank the artist himself who has offered us his full support at every stage of the preparations and has allowed us on several occasions to visit him in his studio and see the work in progress. We would especially like to thank Pat Cunningham, his studio assistant of more than 30 years, Tony's assistant Ellie Oliver and all the studio staff, as well as Hans Spinner for making the ceramic parts. We would like to express our gratitude to Dave Hickey who has written an illuminating and insightful essay which sets the arrival of Anthony Caro's Barbarians firmly in the 21st century.

Lucy Mitchell-Innes, Annely and David Juda
October 2002

ANTHONY CARO

A Biographical Survey

1924 Born 8 March, New Malden, Surrey.

1937-42 Charterhouse School, Godalming, Surrey.
During vacations works in studio of the sculptor Charles Wheeler.

1942-44 Christ's College, Cambridge; M.A. in engineering.
During vacations attends Farnham School of Art.

1944-46 Fleet Air Arm of Royal Navy.

1946-47 Regent Street Polytechnic, London: studies sculpture under
Geoffrey Deeley.

1947-52 Royal Academy Schools, London.

1949 Marries the painter Sheila Girling (two sons Timothy, 1951, and Paul, 1958).

1951-53 Works as part-time assistant to Henry Moore.

1953-79 Teaches two days weekly at St. Martin's School of Art, London.

1954 Moves to Hampstead; models figurative sculpture in clay and plaster.

1956 First one-man exhibition, at Galleria del Naviglio, Milan.

1957 First one-man show in London, at Gimpel Fils Gallery.

1959 Wins sculpture prize at Paris Biennale.
Meets Clement Greenberg in London.
Visits USA for the first time on Ford Foundation English Speaking Union
Grant; meets Kenneth Noland and David Smith, also Robert Motherwell,
Helen Frankenthaler and others.

1960 Returns to London; makes first abstract sculptures in steel including
Twenty Four Hours.
Visits Carnac, Brittany, studies the menhirs and dolmens.

1961 First exhibits a steel sculpture, *The Horse*, 1961, in *New London Situation*,
Marlborough New London Gallery, London. First polychrome sculpture,
Sculpture Seven.

1963 One-man exhibition of abstract steel sculptures at Whitechapel Gallery,
 London.

1963-65 Teaches at Bennington College, Bennington, Vermont.
 Renews contact with Noland and Smith.

1964 First one-man exhibition in New York, at André Emmerich Gallery.

1965 Exhibits *Early One Morning*, 1962, in *British Sculpture in the Sixties*, Tate
 Gallery, London.

1966 Exhibits in *Five Young British Artists*, British Pavilion, Venice Biennale (with
 painters Richard Smith, Harold Cohen, Bernard Cohen and Robyn Denny).
 Begins first table sculptures.

1967 Retrospective exhibition at Rijksmuseum Kröller-Müller, Otterlo.
 Acquires stock of raw materials from estate of David Smith.

1969 Retrospective exhibition at Hayward Gallery, London.
 Appointed Commander of the Order of the British Empire.
 Exhibits, with John Hoyland, in British Section of Tenth São
 Paulo Biennale.
 Patrick Cunningham becomes Caro's studio assistant.

1970 Begins making unpainted steel sculptures.

1972 Makes sculptures using roll end steel at Ripamonte Factory, Veduggio,
 Brianza.

1973 One-man exhibition at Norfolk and Norwich Triennial Festival, East Anglia.
 Museum of Modern Art, New York, acquires *Midday*, 1960.

1974 Works at York Steel Co., Toronto, and makes large sculptures, assisted by
 sculptors James Wolfe and Willard Beopple.

1975 Retrospective exhibition at Museum of Modern Art, New York (which later
 travels to Walker Art Center, Minneapolis, Museum of Fine Art, Houston,
 and Museum of Fine Art, Boston). Works in clay at workshop of Syracuse
 University, New York, organised by Margie Hughto.
 Begins making sculptures in welded bronze.

1976 Presented with key to the City of New York by Mayor Abraham Beame.

1977 Exhibition of table sculptures at Tel Aviv Museum, later tours Australia,
 New Zealand and Germany.
 Artist in residence at Emma Lake summer workshop, University of
 Saskatchewan.

1978 Makes first 'writing pieces': calligraphic sculptures in steel.
 Executes commission for East Wing of the National Gallery, Washington.

1979 Receives Honorary Doctorates from East Anglia University, Norwich, and York University, Toronto.
Made Honorary Member of American Academy and Institute of Arts and Letters, New York.

1980 Makes first sculptures in lead and wood.

1981 Makes wall pieces in handmade paper, with Ken Tyler in New York.
Exhibits at Städelsches Kunstinstitut und Städtische Galerie, Frankfurt.
Made Honorary Fellow, Christ's College, Cambridge.

1982 Appointed Trustee of Tate Gallery, London.
Initiates Triangle annual summer workshops for sculptors and painters at Pine Plains, New York.
Joins Council of Slade School of Art, London.

1984 One-man exhibition at Serpentine Gallery, London, which travels to Copenhagen, Düsseldorf and Barcelona. Creates first sculpture with an architectural dimension: *Child's Tower Room.*

1985 Visits Greece for the first time.
Leads Sculptors' Workshop, Maastricht.
Receives Honorary Doctorate from Cambridge University.

1986 Completes work on *Scamander* and *Rape of the Sabines*, first of sculptures inspired by Greek pediments.
Made Honorary Fellow, Royal College of Art, London.

1987 Awarded knighthood, Queen's Birthday Honours.
Executes *After Olympia*, his largest one-piece sculpture.
Attends workshops in Berlin and Barcelona.

1989 Exhibits at Walker Hill Art Center, Seoul.
Sculpture workshop, Edmonton.
Visits Korea and India.
Receives Honorary Degree, Yale University, New Haven.

1990 Exhibits at Musée des Beaux Arts, Calais.
Visits Japan and starts series of paper sculptures at Nagatani's workshop, Obama.

1991 Completes work on two large sculptures involving a dialogue with architecture: *Sea Music* for the quayside, Poole, Dorset, and *Tower of Discovery* for an exhibition of recent work at the Tate Gallery, London.

1992 Retrospective exhibition at the Trajan Market, Rome, organised by Giovanni Carandente and the British Council.
Made Honorary Member, Accademia di Belle Arte di Brera.
Receives Praemium Imperiale award for sculpture, Tokyo.
Tower of Discovery shown at the World Expo Fair, Seville.

1993-94 The British Council tours a selection of the *Cascades Series* of table pieces to museums in Hungary, Romania, Turkey, Cyprus and Greece.

1994 Receives Honorary Doctorate of the Royal College of Art, London. Several exhibitions organised to celebrate the artist's 70th birthday, including: *The Trojan War*, shown at the Iveagh Bequest, Kenwood, London, and the Yorkshire Sculpture Park, Wakefield; *Sculpture Through Five Decades*, shown at Annely Juda Fine Art.

1994-95 Largest retrospective exhibition held at the Museum of Contemporary Art, Tokyo, curated by Yasuyoshi Saito with special architectural settings by Tadao Ando.
Exhibition of table sculptures organised by Kettle's Yard Gallery, Cambridge University, tours to Whitworth Art Gallery, University of Manchester, and Graves Art Gallery, Sheffield.
The Henry Moore Sculpture Trust commissions a temporary sculpture installation for the Henry Moore Studio at Dean Clough, Halifax: *Halifax Steps—Ziggurats and Spirals*.

1996 Receives Diploma Doctor Honoris Causa, University of Charles de Gaulle, Lille and Honorary Degree, Durham University.
Goodwood Steps displayed at the Hat Hill Sculpture Foundation, Goodwood.

1996-97 The *Trojan War* sculptures are shown in Greece at Thessaloniki and at the National Gallery, Athens.
With the architect Sir Norman Foster and the engineer Chris Wise, wins the competition for a new footbridge spanning the Thames from St. Paul's to the new Tate Gallery of Modern Art at Bankside, London. Completed in 2000, the bridge is known as the 'Millennium Bridge'.

1998 *Caro—Sculpture From Painting* shown at the National Gallery, London, the first occasion a contemporary sculptor has been invited to exhibit there. Receives Lifetime Achievement in Contemporary Sculpture Award, International Sculpture Centre, Washington DC, and Honorary Fine Arts Degree, Florida International University.

1999 Exhibits *The Last Judgement*, 1995-99, a twenty five part sculpture that has been compared to Picasso's *Guernica*, at the 48th Venice Biennale.

2000 Awarded OM.
Exhibition at Venice Design Gallery, Venice of works from the *Concerto* series (1999/2000) inspired by music.
Three from the series of seven *Duccio Variations* in different materials are included in the *Encounters* exhibition at the National Gallery, London.
The *Last Judgement* is the first show in the new wing of the Museo des Bellas Artes, Bilbao.

2001 The *Last Judgement* is exhibited at the Johanniter Kirche, Schwäbisch Hall, Germany to coincide with the opening of the new Kunsthalle Würth.

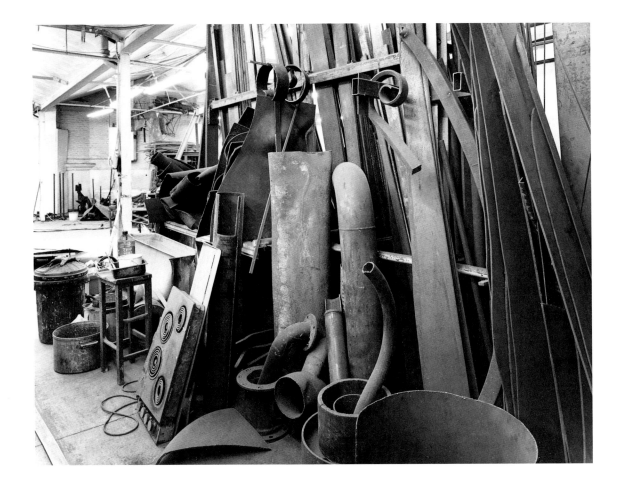

An educational exhibition *A Sculptor's Development—Anthony Caro*, is shown in Lewes, Sussex, and Street, Somerset
Exhibitions at Marlborough Gallery, New York and Santiago
Caro at Longside: Sculpture and Sculptitecture, exhibition of large architecural inspired works opens new gallery space at Longside, Yorkshire Sculpture Park

2002 Exhibitions at Galería Metta, Madrid, Galleria Lawrence Rubin, Milan and Galería Altair, Palma de Mallorca
Anthony Caro—L'évolution d'un sculpteur exhibition at Château-Musée de Dieppe, France.
Anthony Caro: Drawing in Space—Sculptures from 1964 to 1988 & The Last Judgement, 1996-99, a major survey exhibition is shown at the famous Gaudi 'La Pedrera' building in Barcelona. The exhibition is organised by the Caixa Catalunya who also specially created a new exhibition space adjacent to La Padrera to exhibit the *Last Judgement*.

Public Collections

Aberdeen Art Gallery, Scotland
Akron Art Museum, Ohio
Musée des Beaux-Arts, Angers
Baltimore Museum of Art
Ajuntament de Barcelona
Fundacio Antoni Tapies, Barcelona
Fundacio Joan Miró, Barcelona
Museo de Arte Contemporaneo, Barcelona
Cecil Higgins Art Gallery, Bedford
Sondra & Marvin Smalley Sculpture Garden, University
 of Judaism, Bel Air, California
Ulster Museum, Belfast
Western Gallery, Western Washington University,
 Bellingham
Suzanne Lemberg Usdan Gallery, Bennington College,
 Bennington
Kunsthalle Bielefeld
Birmingham Museum of Art, Alabama
Birmingham Museums & Art Gallery, UK
Cranbrook Art Museum, Michigan
Kunstsammlung der Ruhr-Universität, Bochum
Museum of Fine Arts, Boston
The First Church of Christ Scientist, Boston
Queensland Art Gallery, Brisbane
Sarah Lawrence College, Bronxville, New York
Szepmuveszeti Museum, Budapest
Albright-Knox Art Gallery, Buffalo
Musée des Beaux Arts et de la Dentelle, Calais
Christ's College, University of Cambridge
Fitzwilliam Museum, University of Cambridge
Museo de Arte Contemporaneo, Caracas
Ackland Art Museum, University of North Carolina
Cleveland Museum of Art, Ohio
Museum Ludwig, Cologne
Collection du Fonds Départmental d'Art Contemporain
 du Val de Marne, Creteil
Dallas Museum of Art, Texas
Dayton Art Institute, Ohio
Detroit Institute of Art, Michigan
Skulpturensammlung Albertinum, Dresden
Wilhelm Lehmbruck Museum, Duisburg
Kunstmuseum Düsseldorf

Kunstsammlung Nordrhein-Westfalen, Düsseldorf
Scottish National Gallery of Modern Art, Edinburgh
Edmonton Art Gallery
University of Alberta, Edmonton
Museum of Outdoor Arts, Englewood, Colorado
Museum Folkwang, Essen
Modern Art Museum, Fort Worth, Texas
Fukuoka Art Museum, Japan
Centre for Contemporary Graphic Art & Tyler
 Graphics Archive Collection, Shiota, Japan
Glasgow Museum & Art Gallery
Musée de Grenoble
National Museum of Contemporary Art, Seoul
Hamburger Kunsthalle, Hamburg
McMaster University Museum & Art Gallery, Hamilton
Sprengel Museum, Hannover
Wadsworth Atheneum, Hartford, Connecticut
Kiasma Museum of Contemporary Art, Helsinki
The Lillie and Hugh Roy Cullen Sculpture Garden,
 Museum of Fine Arts, Houston
Israel Museum, Jerusalem
Johannesburg Art Gallery
Nelson-Atkins Museum of Art, Kansas City
Hyogo Prefectural Museum of Modern Art, Kobe,
 Japan
Kaiser Wilhelm Museum, Krefeld
Fondation Veranneman, Kruishoutem, Belgium
Museum Würth, Künzelsau
City Art Gallery, Leeds
Henry Moore Institute, Leeds
Museum Schloss Morsbroich, Leverkusen
Neue Galerie der Stadt Linz, Austria
Arts Council Collection, London
British Museum, London
English Folk Dance & Song Society, London
Government Art Collection, London
Hammersmith & West London College, London
Hampstead Town Hall, London
Millennium Bridge Trust, London
Nature Reserve, Docklands, London
Paintings in Hospitals, Sheridan Russell Gallery,
 London

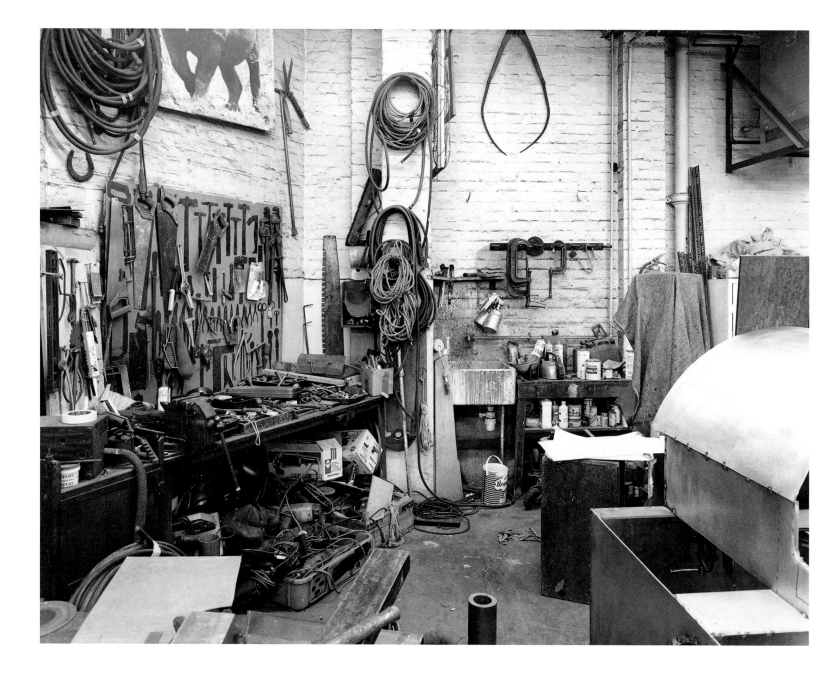

Tate Gallery, London
Tate Gallery Foundation, London
The British Council, London
Victoria & Albert Museum, London
Franklin D Murphy Sculpture Garden, University of
	California, Los Angeles
Frederick R Weisman Art Foundation, Los Angeles
Los Angeles County Museum of Art
Museum of Contemporary Art, Los Angeles
Speed Art Museum, Louisville, Kentucky
Fundacio Arco - IFEMA1, Madrid
Currier Gallery of Art, Manchester, New Hampshire
Whitworth Art Gallery, University of Manchester
Städtische Kunsthalle, Mannheim
National Gallery of Victoria, Melbourne
Walker Art Centre, Minneapolis
Storm King Art Centre, Mountainville, New York
Ball State University, Muncie, Indiana
Bayerische Staatsgemäldesammlungen, Munich
Westfälisches Landesmuseum für Kunst und
	Kulturgeschichte, Münster
Metropolitan Museum of Art, New York
Museum of Modern Art, New York
Solomon R Guggenheim Foundation, New York
Laing Art Gallery, Newcastle-upon-Tyne
Yale University Art Gallery, Newhaven, Connecticut
Sainsbury Centre for Visual Arts, University of East
	Anglia, Norwich
National Museum of Art, Osaka
Shiga Museum of Modern Art, Japan
Kröller-Müller Museum, Otterlo, Holland
Wolfson College, University of Oxford
Ajuntament de Palma, Mallorca
Centre National des Arts Plastiques, Paris
La Défense, Paris
Ministère de la culture, Paris
Musée National d'Art Moderne Centre Georges
	Pompidou, Paris
Peterborough Development Corporation,
	Cambridgeshire
Philadelphia Museum of Art
Carnegie Museum of Art, Pittsburgh
Poole Borough Council, Dorset
Portland Art Museum, Oregon
Sintra Museum de Arte Moderna, Porto, Portugal
Portsmouth City Museum, UK

Frances Lehman Loeb Art Center, Vassar College,
	Poughkeepsie, New York
Rhode Island School of Design, Providence, Rhode
	Island
North Carolina Museum of Art, Raleigh
Red Deer College, Alberta
Virginia Museum of Fine Arts, Richmond
Aldrich Museum of Contemporary Art, Ridgefield
Saarland Museum, Saarbrücken
Mendel Art Gallery, Saskatoon
Ho-Am Art Museum, Seoul
Walker Hill Art Centre, Seoul
Galleria Civica d'Arte Moderna, Spoleto
St Louis Art Museum, Missouri
Staatsgalerie Stuttgart
Northern Centre for Contemporary Art, Sunderland
Art Gallery of New South Wales, Sydney
Everson Museum of Art, Syracuse, New York
Syracuse University, New York
Tel Aviv Museum of Art, Tel Aviv
Hakone Open Air Museum, Kanagawa
Museum of Contemporary Art, Tokyo
Setagaya Art Museum, Tokyo
Tokyo International Forum
Toledo Museum of Art, Ohio
Art Gallery of Ontario, Toronto
York University, Toronto
Museum of Modern Art, Toyama
Vancouver Art Gallery
Peggy Guggenheim Collection, Venice
Museum Moderner Kunst Stiftung Ludwig, Vienna
Museum of Modern Art, Wakayama
City Art Gallery, Wakefield
Wakita Museum of Art, Japan
Rose Art Museum, Brandeis University, Waltham,
	Massachusetts
Hirshhorn Museum & Sculpture Garden, Smithsonian
	Institution, Washington, DC
National Gallery of Art, Washington, DC
The Phillips Collection, Washington, DC
Hartford Art School, West Hartford, Connecticut
Usdan Center for the Creative & Performing Arts,
	Wheatley Heights, New York
Von der Heydt Museum, Wuppertal
Kunsthaus Zürich

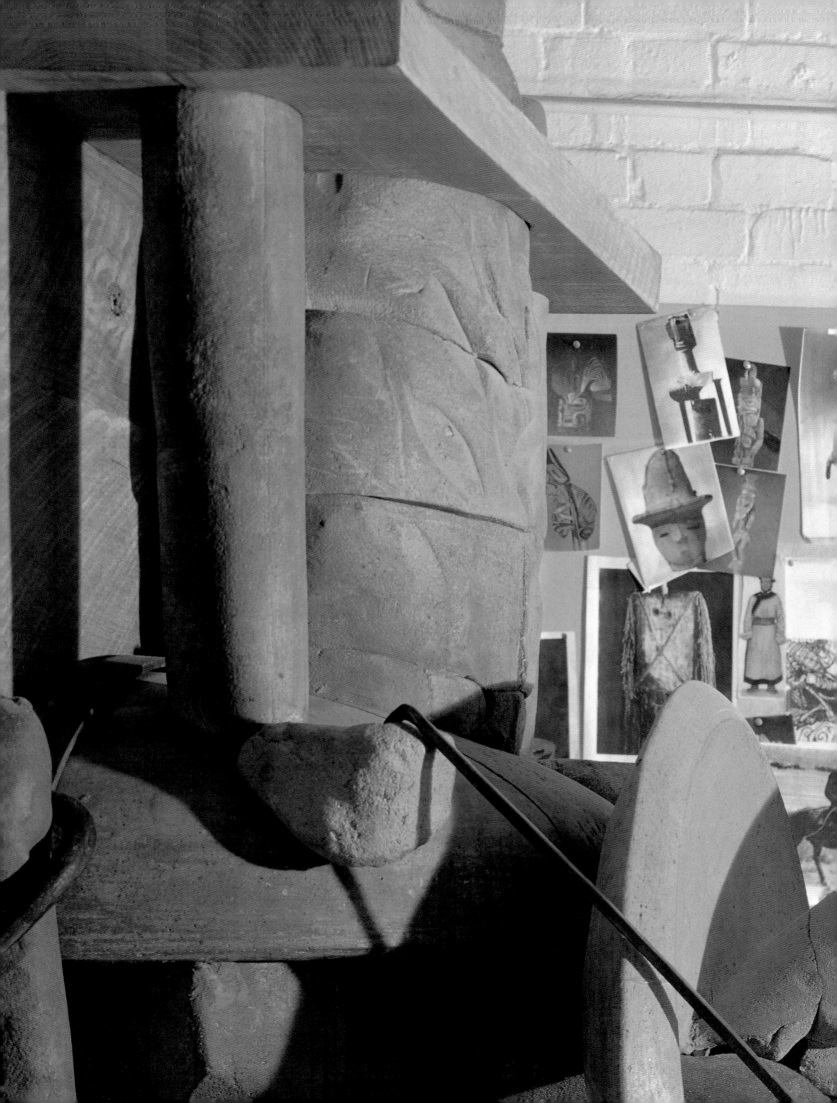

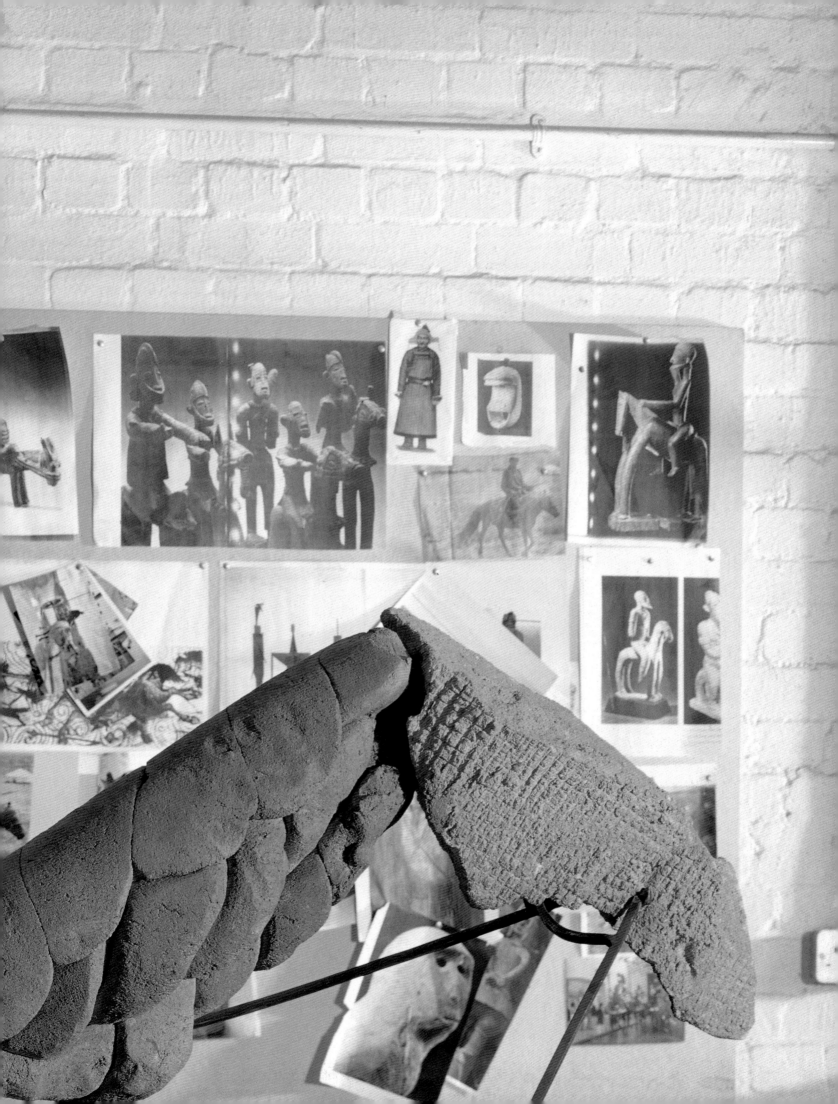

The Barbarians, 1999-2002

Page 23
GOLOM (leather saddle cloth)
Terracotta, wood, leather and steel
74³/₄ x 59 x 54¹/₄ in. (190 x 150 x 138 cm.)

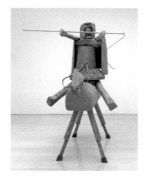

Page 25
SULDE (spirit or symbol or emblem)
Terracotta, wood, leather and steel
80 x 102³/₈ x 60⁵/₈ in. (203 x 260 x 154 cm.)

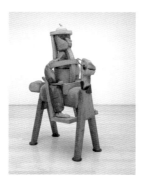

Page 27
KHARJAAR (halter)
Terracotta, wood, leather and steel
80¹/₄ x 60¹/₄ x 35 in. (204 x 153 x 89 cm.)

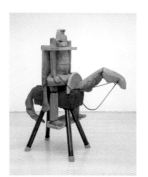

Page 29
JILOO (rein)
Terracotta, wood, leather and steel
78 x 65 x 39³/₈ in. (198 x 165 x 100 cm.)

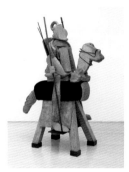

Page 31

SAARDAG (quiver of arrows)

Terracotta, wood, leather and steel

80 x 55 x 31½ in. (203 x 140 x 80 cm.)

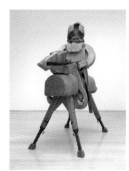

Page 33

DOROO (stirrups)

Terracotta, wood, leather and steel

83½ x 96½ x 37⅜ in. (212 x 245 x 95 cm.)

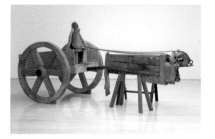

Page 34-35

KHARSAG (a traditional Mongolian cart made of wood)

Terracotta, wood, leather and steel

63 x 141½ x 71⅝ in. (160 x 359 x 182 cm.)

The Mongolian titles are intended to identify the individual
sculptures. The group of seven works are conceived as a
single entity: "The Barbarians."

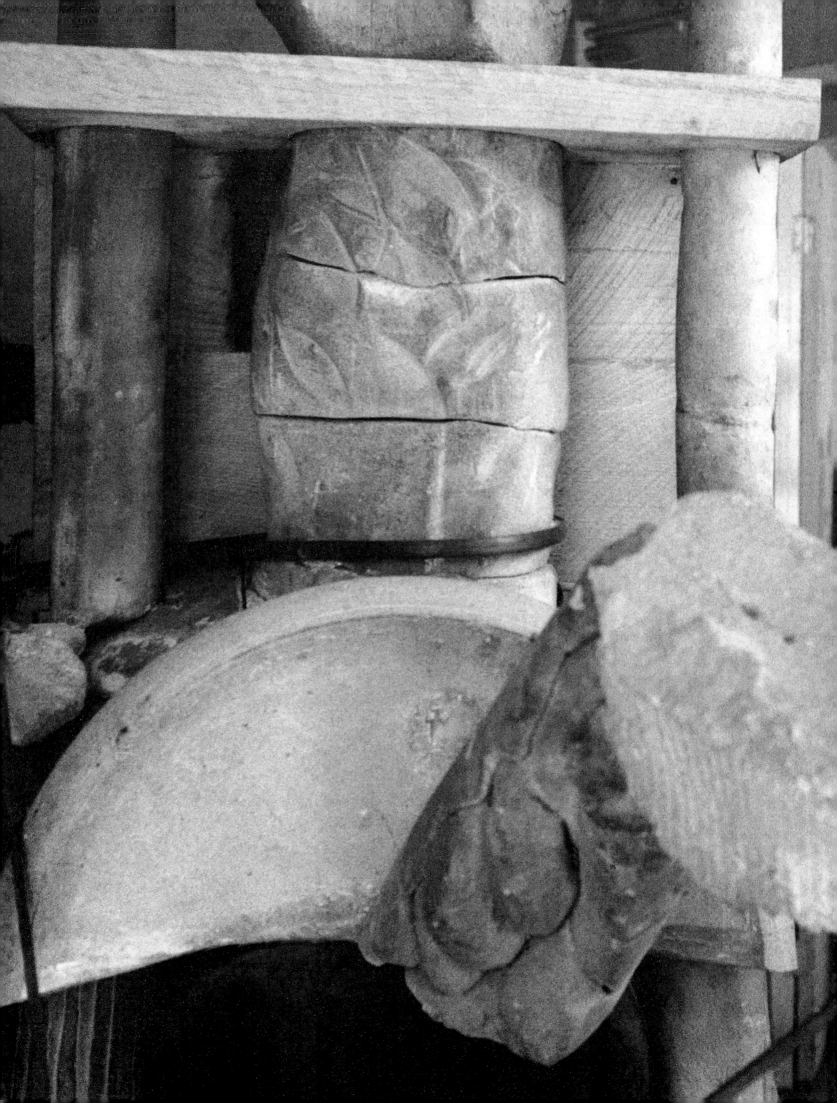

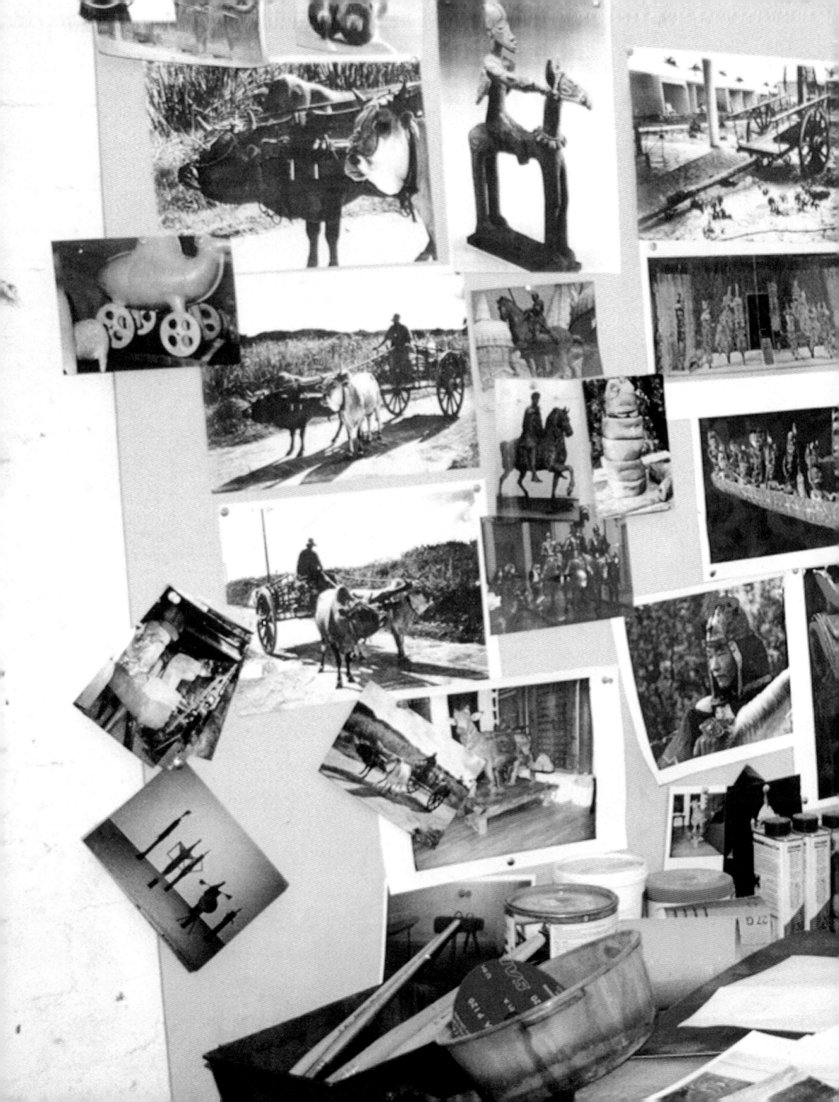

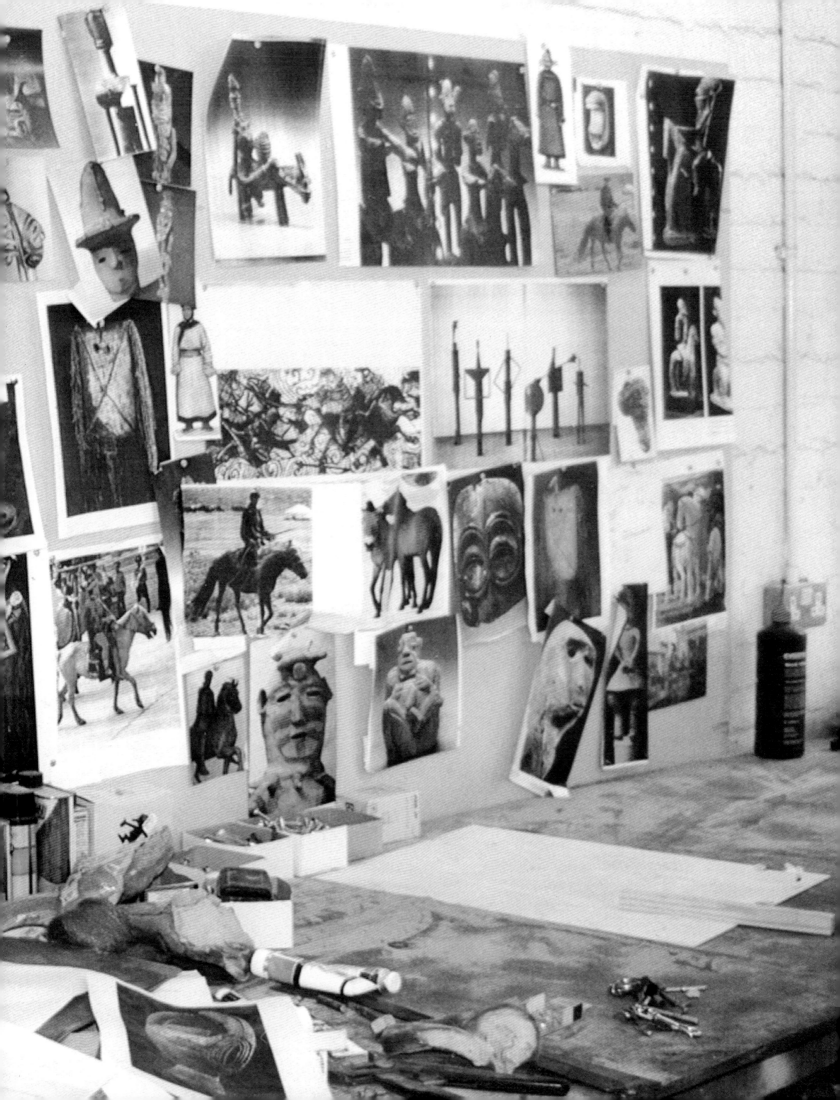

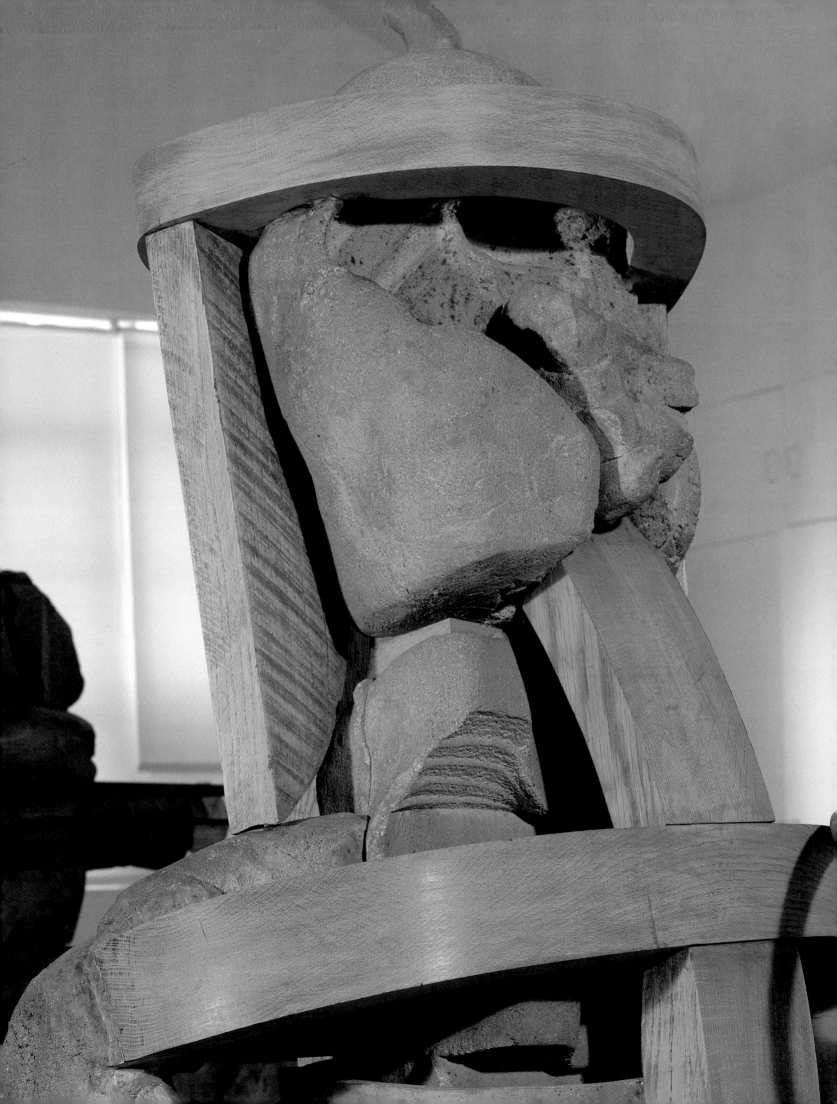

This catalogue was published on the occasion of the exhibition

ANTHONY CARO: THE BARBARIANS

at Mitchell-Innes & Nash
November 1 – December 20, 2002

at Annely Juda Fine Art
March 5 – April 17, 2003

Publication © 2002 Mitchell-Innes & Nash / Annely Juda Fine Art
Essay © 2002 Dave Hickey

Waiting for the Barbarians by Constantine P. Cavafy:
Translation © 1975, 1992 by Edmund Keeley and Philip Sherrard

The Age of Anxiety, by W. H. Auden © 1976, 1991 by the
Estate of W. H. Auden

All works © Anthony Caro

Design: Dan Miller Design, New York
Printing: Druckerei Heinrich Winterscheidt GmbH, Düsseldorf

ISBN 0-9713844-6-0

MITCHELL-INNES & NASH
1018 Madison Avenue New York NY 10021
Tel 212-744-7400 Fax 212-744-7401
Email info@miandn.com
Web www.miandn.com

ANNELY JUDA FINE ART
23 Dering Street London W1R 9AA
Tel 020 7629 7578 Fax 020 7491 2139
Email ajfa@annelyjudafineart.co.uk
Web www.annelyjudafineart.co.uk

Available through D.A.P/Distributed Art Publishers
155 Sixth Avenue 2nd Floor New York NY 10013
Tel 212-627-1999 Fax 212-627-9484

Photography: John Riddy, Richard Elliott and Danny Bird

Page 44: photo by André Emmerich

Pages 50 and 52: photo by Terry Buchanan